IMAGES
of America

ALONG THE
ROUTE 100 CORRIDOR

IMAGES
of America

ALONG THE
ROUTE 100 CORRIDOR

Patricia A. Stompf Blackwell

ARCADIA

First published 2004
Reprinted 2004

Published by Arcadia Publishing,
Charleston SC, Chicago IL, Portsmouth NH, San Francisco CA

Printed in Great Britain

Library of Congress Catalog Card Number: 2004105911

For all general information, contact Arcadia Publishing:
Telephone 843-853-2070
Fax 843-853-0044
E-mail sales@arcadiapublishing.com
For customer service and orders:
Toll-free 1-888-313-2665

Visit us on the Internet at www.arcadiapublishing.com

CONTENTS

Acknowledgments 6

Introduction 8

1. Bally 9

2. Barto 57

3. Bechtelsville 73

4. New Berlinville 81

5. Boyertown 89

ACKNOWLEDGMENTS

This book is dedicated to my late father, Alex J. Stompf. Alex was well known in the area, as he worked at Leo Reppert's Grill at the Bally Fire Company. But many did not know that he was a World War II hero, receiving a battlefield commission of second lieutenant and the Bronze Star for his actions on December 2, 1944.

In the 1944 *Stars and Stripes* newspaper, the award citation reads:

"Staff Sergeant Alex J. Stompf, 405th Infantry, for heroic achievement in connection with military operations against the enemy. When his platoon guide became a casualty, he immediately assumed duty as platoon guide. When the need for ammunition became acute and with utter disregard for his personal safety, he personally led and supervised a carrying party over open terrain swept by enemy machine gun fire and succeeded in bringing ammunition forward and delivering it to front line units, enabling them effectively to continue their operations." My dad never spoke about the war.

Also, many did not know that Alex and his siblings were raised in a German Catholic orphanage, St. Vincent's Home for Boys in Tacony (Philadelphia area). The lack of knowledge about my father's early years has instilled in me a great interest in history and a desire to study the past. My mother, Helen (Benfield) Stompf, worked tirelessly, sometimes 18 hours a day, as a home worker (looper) while also raising our family.

There are so many people to thank. First and foremost, I am grateful to the Lord, without whose guidance *Along the Route 100 Corridor* would not have been written. To my husband, Bill Blackwell, who has encouraged me every step of the way and loved me through the months of research and late nights at the computer. To my children, Ryan and Jaime Freese, who now have a glimpse of the area. And to my in-laws, Bill and Helen Blackwell, for their prayers and guidance.

Thanks to the following people who were instrumental in providing information and photographs: Brian Quigley of Quigley Chevrolet; Burt Harries of Bally Ribbon Mills; Dan Kuser and James Reichert of Bally Block; Steve Longacre of Longacre Electric; Newton Longacre of Longacre Dairy; Luella Gehman of Gehman Family Photographs; Eugene Smith of Bally; Toni Hamerka of the borough of Bally; my cousins Sharon Boyer and Tessie Kriebel; Mark, Carole, and Steven Shearer of Shearer Technical; Charlie Adams, who has given me tips, and has had many works published throughout the years; and Debra Deysher of Double D Media.

I am especially grateful to Larry Kemmerer, who shared his time and knowledge of the area, especially Barto, the hometown of his family. The photographs from his collection are a major part of *Along the Route 100 Corridor*.

Finally, to my Dad: "I did it."

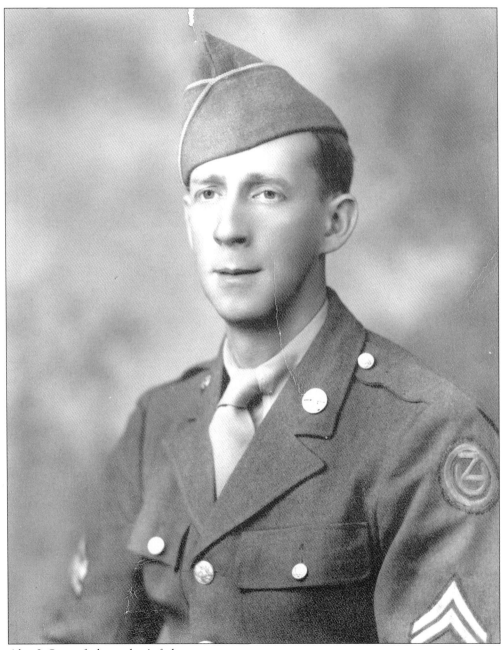

Alex J. Stompf, the author's father.

INTRODUCTION

Imagine you are back in time, living in the 1800s, and you are strolling down the streets of Boyertown dressed in the finest attire of the day. If you are a lady, you wear a long dress with a beautiful hat. It is warm today, so you need your frilly umbrella to protect you from the blazing sun. If you are a gentleman, you don a dark wool suit, white shirt, and straw hat. You walk to the local grocer to pick up a few staples to provide a tasty meal for your family.

Along the Route 100 Corridor will transport you back to these times and more—from the 1700s to the late 1940s. You will witness the changes in the modes of transportation: from the early horse-and-buggy days, to the Model T's first sold at Quigley Ford in Bally, to the first introduction of automobiles at Quigley Chevrolet.

Think about walking several miles in all types of weather, including several feet of snow, to get to school. In those days, your goal was to reach the one-room schoolhouse. Many children had to help on the family farms and only attended school through the fourth or fifth grade. Getting to the eighth grade was a privilege only afforded a few.

What was Thomas Edison's connection to the Bechtelsville area? How many families would be wholly lost in the Rhoad's Opera House fire? What ever happened to the young Mennonite missionary girl who traveled to India by herself? These questions are all explored here, in these pages.

You will soon see how the Berks County area of Pennsylvania contributed to many famous firsts. While looking through this history, ponder these times of years long gone and compare them to our lives and luxuries of today.

—Patricia (Stompf) Blackwell

One
BALLY

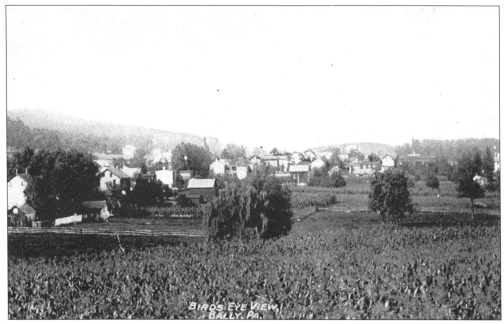

This crow's-eye-view photograph of the homes in Bally was taken from what is still known as Crow Hill. Crow Hill includes the stretch from North Sixth Street (later changed to North Church Street) toward Forgedale.

In 1883, a post office opened with the designation "Bally" in Churchville. The post office was located behind the bank on South Sixth Street (later known as South Church Street). Later, the name of the town itself was also changed to Bally. The name had been chosen to honor the recently deceased Fr. Augustin J. Bally, a priest and spiritual leader of the town's Catholic church. When the community was first settled by Mennonites and Catholics in the early 1700s, the town was originally known as Goshenhoppen, a Native American name meaning "meeting place." Some years later, Goshenhoppen was renamed Churchville to reflect the many churches in town, and thereafter, it became known as Bally.

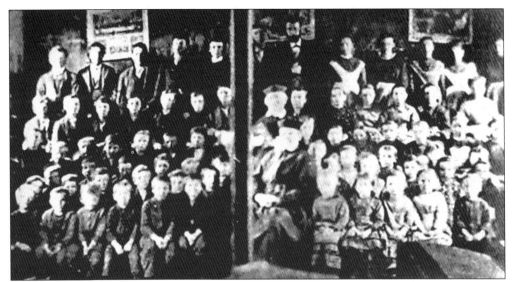

This is a view of the first primitive school in Bally, with children gathered around the priests and parish lay teachers, or "schoolmasters" as they liked to be called. Father Bally used every means in his power to promote the use of English in the school since German was the common language in Washington Township at the time. Some of the schoolmasters were Nicholas Andre (who started teaching before 1860), Jerome Stengel (who taught between 1858 and 1862), Samuel Witman, George W. Melchior, and James Kase (who began teaching in 1879).

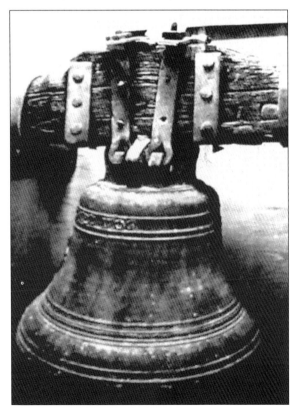

The bell shown was cast in Paris, France, in 1706. It was brought to Bally in 1741 for the town's first chapel, the original Chapel of St. Paul. Fr. Theodore Schneider, a Jesuit priest, came to the area in 1741 to establish what would be the third Catholic mission in the 13 original colonies. On land received from the Mennonite community, Father Schneider built St. Paul's Chapel in 1743. Little is known of the circumstances leading to the first purchase of land at Goshenhoppen by Father Schneider.

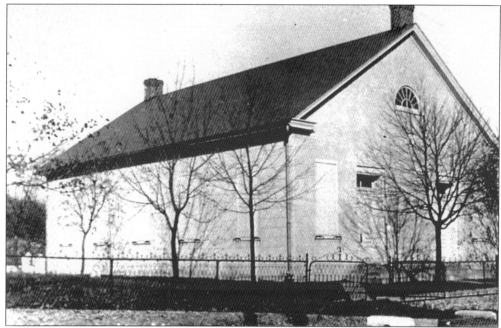

The first meetinghouse was constructed in 1732 on land owned by Ulrich Beidler for which no deed was issued. On March 1, 1747, Beidler sold his land to Henry Neale, a Catholic from Philadelphia. In 1755, George Bechtel bought one acre and nine perches for two pounds and 10 shillings, and the tract was donated to the congregation. Several meetinghouses were constructed during the late 1700s, and then, in 1899, the meetinghouse that is pictured here was built on Main Street in Bally.

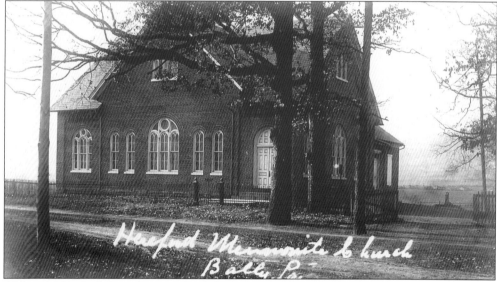

Although Hereford Township was divided in 1839, the official name of the Hereford Mennonite Church was retained. A separation of sorts occurred in 1849, with the "old" and "new" Mennonites forming separate congregations. The "old" Mennonite group continued to occupy the plastered stone structure on Main Street (shown in previous photograph). In 1971, the "new" Mennonites built this house of worship at the entrance to Old Route 100 and Barto Road.

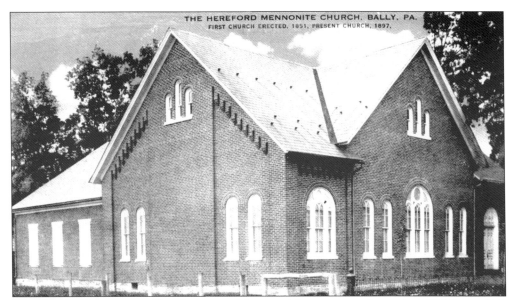

The Hereford Mennonite Church, home of the new Mennonites, is located on Old Route 100. The original Hereford cemetery is believed to have opened sometime between 1729 and 1747. It is located next to the church and the old meetinghouse on Main Street, at the entrance to Old Route 100 and Barto Road.

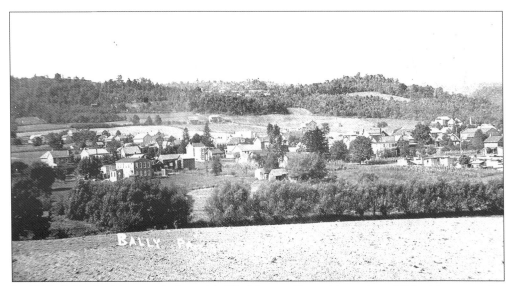

In 1912, Bally shed its association with Washington Township and established its governing body as a borough. Throughout the years, Bally has been known as an area rich in heritage, where people of different religious backgrounds live and work together in harmony. It is home to farmers, artists, and blue-collar workers.

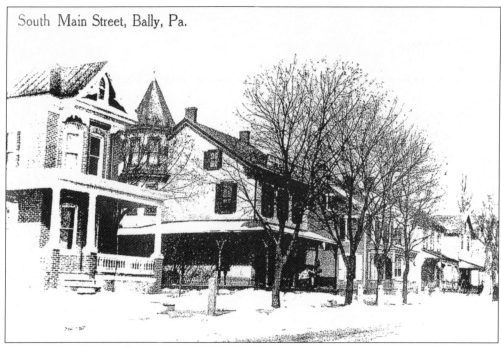

South Main Street, Bally, Pa.

Traveling north on Bally's primary roadway, this view depicts the 500 block of Main Street. The homes pictured here still remain. On the left side of the street, Gehman's Store is shown. The last structure on the right, at the end of the block, is Bechtel's Store.

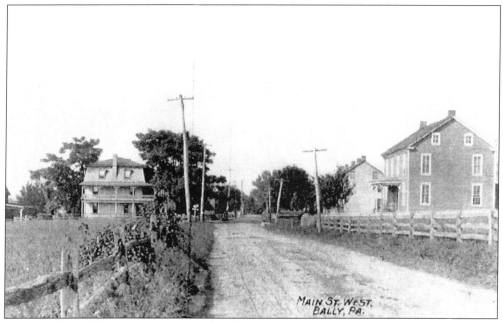

MAIN ST. WEST.
BALLY, PA.

This view of Bally looks south on Route 100 (Main Street), heading to Seventh Street. In the distant left, the Union House (later the Bally Hotel) appears on the corner of Seventh and Main.

This northward view on Main Street between Sixth and Seventh Streets shows, from left to right, Charles Fronheiser's IGA store, the Fronheiser residence, the home of the Cyril Kehs family, and the Melcher residence (hidden behind trees). Not visible in this photograph, but also located on this side of Main Street, traveling north, would have been First National Bank (later Longacre Electric), Quigley Ford (next to Fronheiser's store), the homes of the James Quigley family and the William Quigley family, and finally, Horace Quigley's Union House.

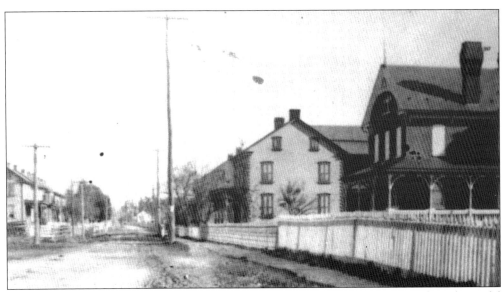

This additional view shows the right side of the 500 block of Main Street, with its beautiful white-gated homes.

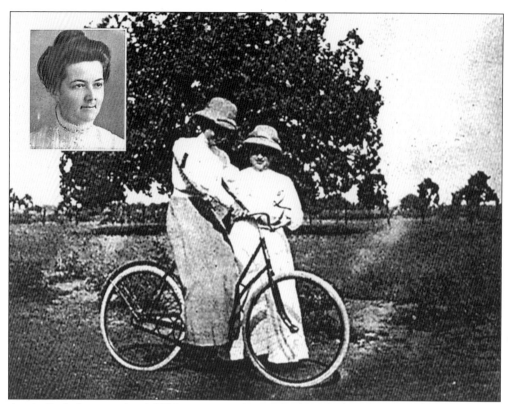

Annie Funk, born in April 1874, was a member of the Hereford Mennonite Church in Bally. In 1906, she became the first female Mennonite missionary to go to India. While there, Annie worked with lepers and set up a school for girls in Janigir, in Central India. Children from the Bally Mennonite community raised money to purchase a bicycle for Annie. She was often seen with her bicycle, her Bible, and a portable organ. In 1912, Annie received a telegram from her pastor stating that her mother was ill and that she should return home. Upon arriving in England, Annie was to depart for the United States on a certain ship. However, a coal workers' strike prevented that ship from leaving port. Desiring to return home as quickly as possible, she became a second-class passenger aboard the *Titanic*, on which she celebrated her 38th birthday. After the *Titanic* struck the iceberg and was sinking, Annie gave up her lifeboat seat to a mother and child. Subsequently, Annie perished on April 15, 1912, and her body was never recovered.

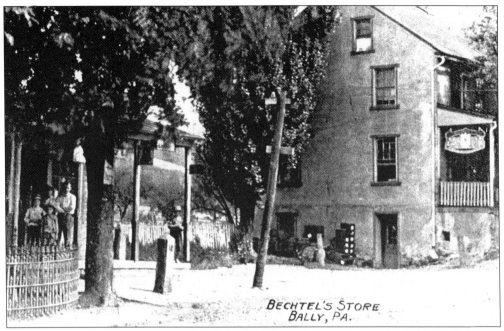

This is one of the oldest photographs of the initial wood-structured Bechtel's Store (left) and the Union House (right), both located on the corners of then dirt lanes Sixth and Main.

Russell and Stanley Bechtel appear with their mother at their home on Main Street. Stanley later took ownership of the family store.

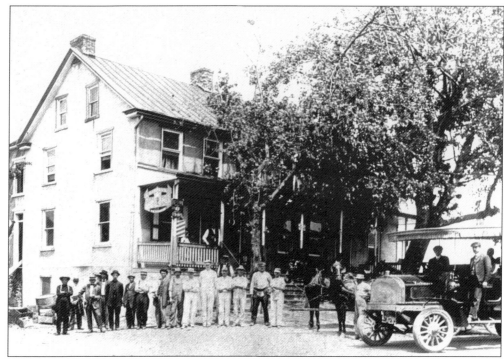

Gus Spaar was the first owner of the Union House, pictured here, located at the corner of Sixth and Main Streets. He later moved to Hereford and sold the hotel to Horace Quigley. The barn behind the Union House was a livery, which provided travelers with a place to board their transportation. The Most Blessed Sacrament Church held school at the hotel for a brief time *c*. 1916, when the third floor of the old school was condemned. This same building was later remodeled into an apartment dwelling.

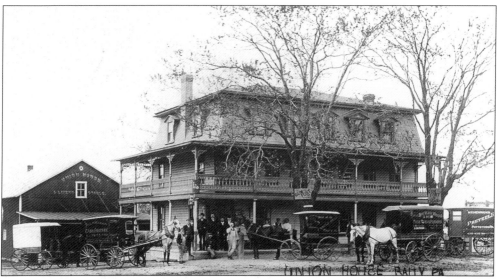

Horace Quigley sold the first Union House hotel, and built the second, shown here, at the corner of Main and Seventh Streets. At one point, the hotel offered travelers livery service (horse and buggy) from the Barto railroad station.

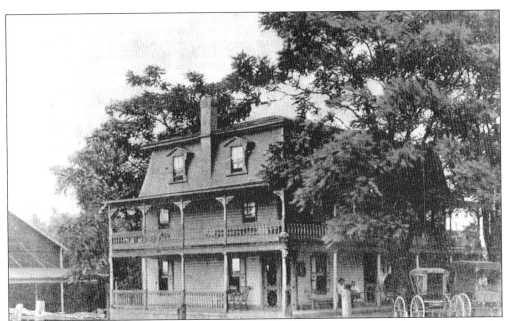

Shown here is the Seventh and Main Street location of the Union House. For many years, the upper level was used as a rooming house, and, later on, apartments for families. Today, after several renovations, the Union House is still a famous restaurant and bar. The uniqueness of the building's structural design remains.

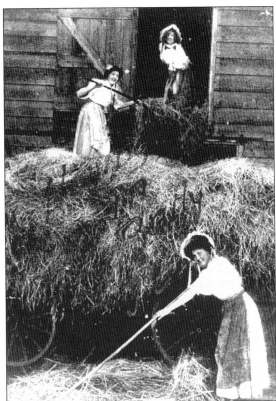

Local women worked at the Union House's livery building by baling and delivering hay and straw needed for boarding of the horses.

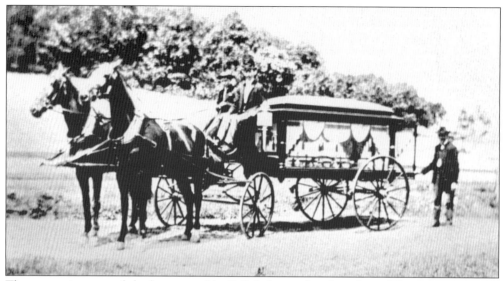

These two views reveal the hearse used by Bally's first undertaker, Amos Witman.

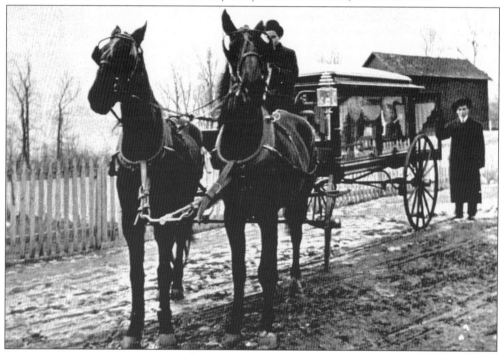

Amos Witman, the local undertaker, made caskets by hand. He resided on North Sixth Street (now North Church Street), where his house still remains as a private residence.

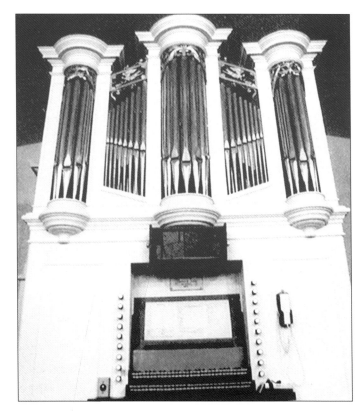

The Krauss organ at Most Blessed Sacrament Church was built between 1797 and 1799. It is the largest and only one of three still played every Sunday. The organ originally had one manual keyboard, a 13-note pedal board, 10 stops, and 500 pipes. A second manual board and a larger, 18-note pedal board were added sometime before 1865 by a grandson of the Krauss brothers.

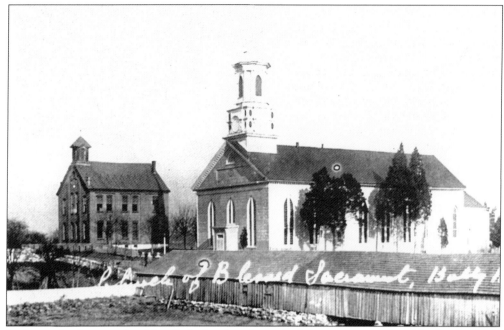

In this early photograph of the Catholic church, to the left one can see the old school, which was the early school with three floors. The third floor was removed when it was deemed unsafe, reducing the building to two floors. This scene is viewed from the area that is now the Catholic cemetery. In the foreground, the back of the carriage sheds line the dirt road.

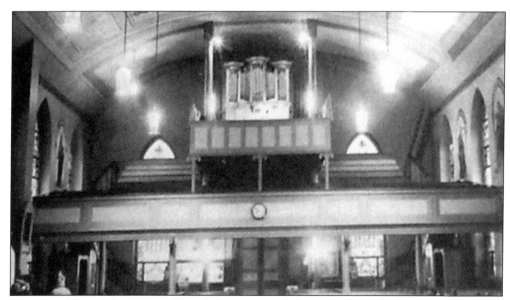

The Most Blessed Sacrament Church has remained the same through the years. This view depicts the choir loft and Krauss organ. For many years, students from the Catholic school were singers in the church choir and were instructed by Sr. Theonilla, a Franciscan nun.

Shown here is the front entrance to the Bally Museum and Library, adjacent to the original Chapel of St. Paul. For many years, this served as a classroom for students attending the Catholic school. It is quite primitive, with the original wood floor set down with old square-headed nails. The building was also used to house the various housekeepers who served the resident pastor.

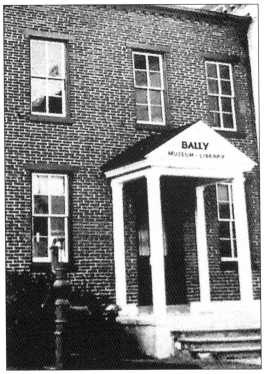

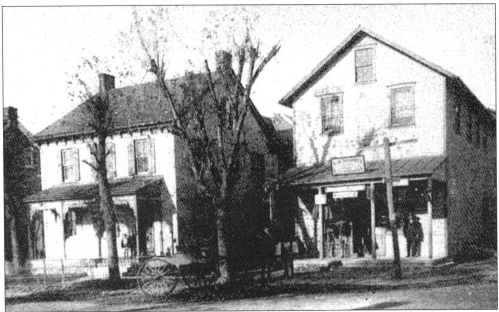

The Bechtels ran the first post office in the back of their family store for years. The original shop, located at Main and Church Streets in Bally and pictured here, burned to the ground as a result of a 1912 blaze. Fire apparatus from Pottstown (15 miles away) was transported via the railroad as far as Barto, and a team of Nicholas Melcher's horses pulled the equipment from Barto to the fire. A new store was built on the same site. The Bechtel family home is shown on the left, and the store/post office building is on the right.

The original Bechtel family residence is pictured here. Later, Stanley and his wife, Dorothy, resided in the home next to the store. Dorothy was well known as the local piano teacher, instructing students throughout Berks County.

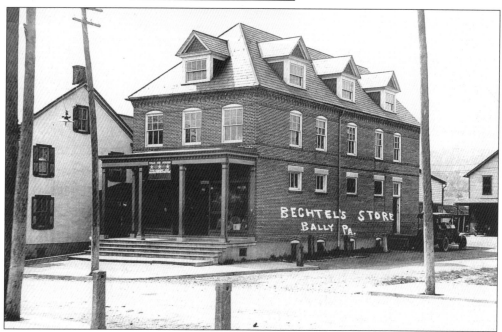

Stopping by to visit with Stanley Bechtel was always a child's treat, since Bechtel had penny candy in a glass-enclosed counter by the cash register. For a nickel, one could buy more than a handful of candy. In the back of the store, there were large containers of pretzels that could be purchased by the pound.

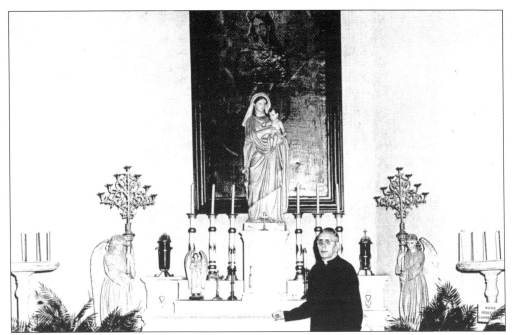

The original Chapel of St. Paul in Goshenhoppen was built in 1743. The altar and its wooden candlesticks and candelabra are originals. The tombstones over the graves of the first missionaries are located in the front of the sanctuary. Monsignor Charles Allwein, shown here, was appointed administrator of the parish in 1930.

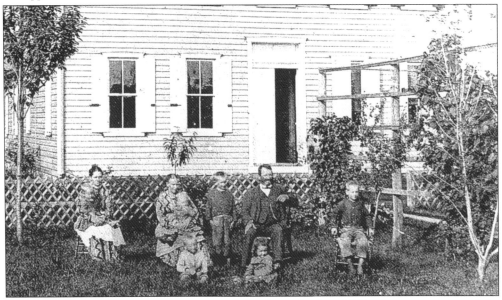

Jacob and Ellen Gilberg represent a typical family in the late 1800s. It was not unusual for families to have as many as 12 to 16 children, but in the early years, there was a high death rate due to diphtheria epidemics, pneumonia, and other ailments. Members of the Gilberg clan pictured here are, from left to right, as follows: (first row) John and Catherine; (second row) a maid holding Rosa (the great-grandmother of the author), mother Ellen holding Mary, Peter, father Jacob, and Joseph. Another daughter not shown, Sally, died at a very early age.

Pennsylvania German was the primary language spoken by the community's first settlers, and continues to be spoken by a select few in the area; therefore, the school was known as "Die Alte Schule." The English translation, "the old school," is the term people still use when referring to the school. On August 8, 1941, at the Most Blessed Sacrament Church bicentennial celebration, Cardinal Dougherty, archbishop of Philadelphia, remarked, "As far as the Thirteen Original Colonies are concerned, your parochial school must have been one of the first, if not the first, within their bounds." The 250th anniversary of the first parochial school in the United States was celebrated on October 24, 1993.

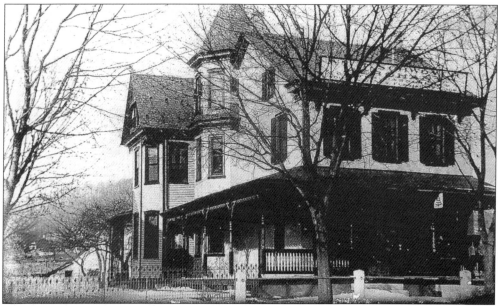

Gehman's Store on Main Street was the area's most unique little general store, and it was one that everyone patronized. Anyone who required "spectacles," as they were called at the time, would visit Eli Gehman. The original store, opened by Enos Gehman and known specifically for watch repair, was also located on Main Street, a short distance from the present store.

26

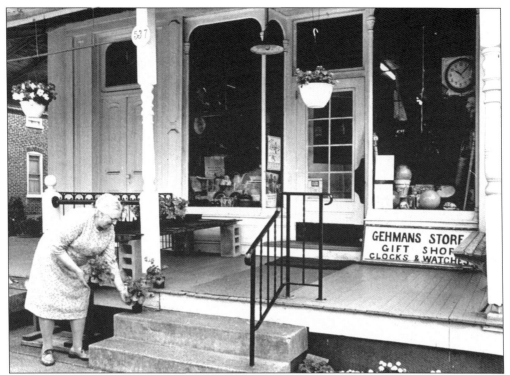

Gehman's Store has been popular with local residents from its early beginnings. Even today, it remains owned and operated by the Gehman family, having passed from fathers to sons to daughters. Schoolchildren always dropped by to visit Sarah and to purchase items such as pencils, erasers, rulers, and paper. Gehman's carried a little bit of everything.

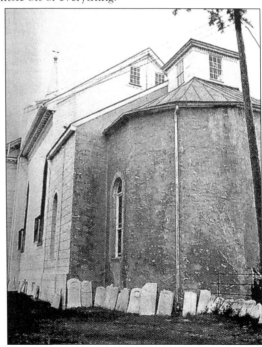

This back view of Goshenhoppen's original chapel building, erected in 1743, shows the first enlargement in 1796, and the final addition in 1837.

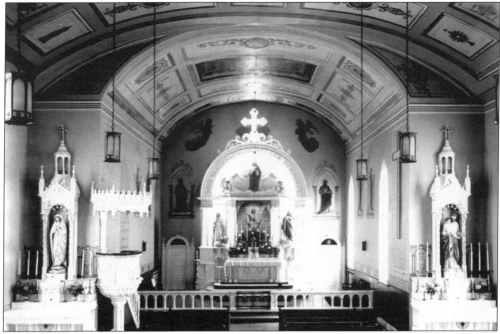

The interior of the Most Blessed Sacrament Church is magnificent, with the hand-painted ceiling, stained-glass windows, and paintings of the Stations of the Cross. Masses were said in Latin for many years, and the historical nature of the church and school has brought thousands of visitors over the years.

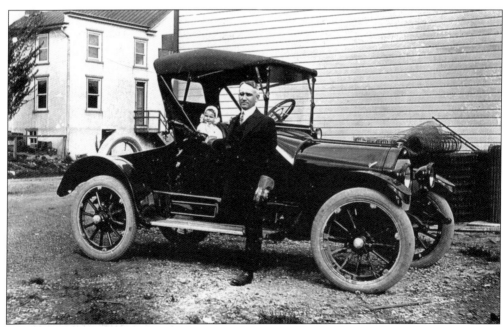

Gone are the days when the local doctor made house calls. Dr. Bergey, shown here, was one of the first physicians in the area. Dr. Yeagle was the first doctor in Bally.

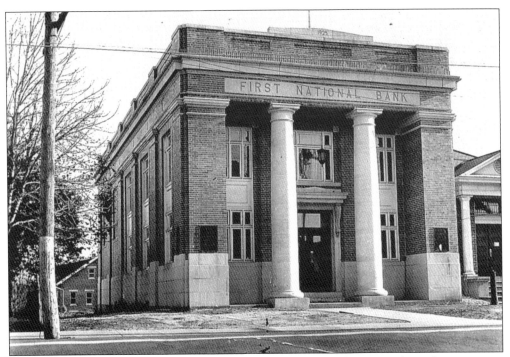

The First National Bank, located on the corner of Main and Sixth Streets, showed great success in 1939. Deposits totaled more than $835,000. T. W. Kinney was the president of the bank at that time. Note the small structure on the right; this one-story brick building was the original quarters of the bank. Dr. O. W. Berky was the burgess at the time, and Bally's government housed itself in the small former bank building.

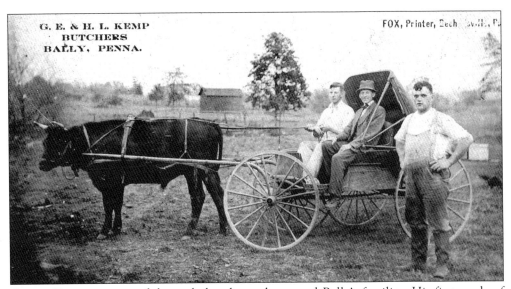

George Kemp was one of the early butchers who served Bally's families. His first mode of transportation is depicted here. Families relied on the butcher to make his twice-weekly stops at their homes to bring fresh meats. Local favorites included Pennsylvania Dutch scrapple and sausage.

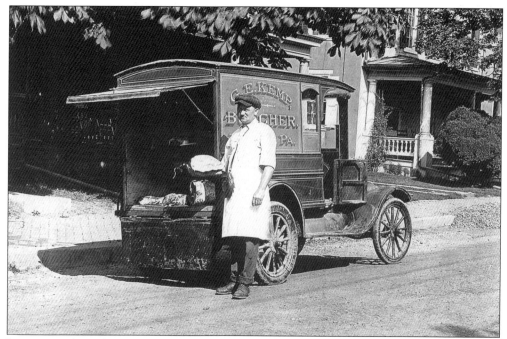

Later years show the transition to the more modern mode of travel for George Kemp and C. Weller, the neighborhood butchers of Bally. The gentleman pictured here is unidentified.

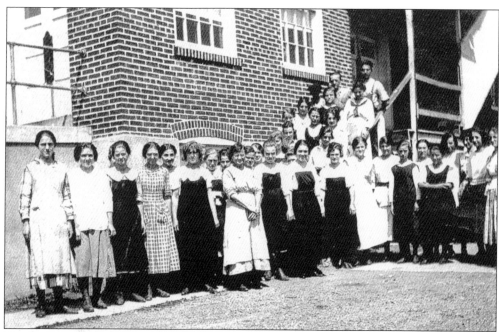

The knitting mills were the main employers of women in the area. This building was the original structure used by Great American for many years. The author's grandmother Mary Benfield is seen 11th from the left. It was not unusual for entire families to be employed at Great American, as exemplified by the Henry sisters: Clara (second from left), Katie (fifth from left), and Lizzie (ninth from left).

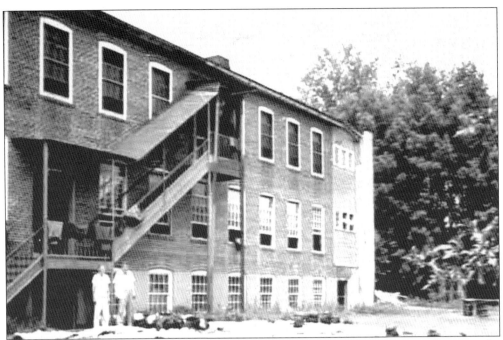

Great American's earliest building was located on South Sixth Street. Most employees at the time were residents of Bally, and since many women did not drive, they walked to work daily. The "gold toe" sock was born during the war, when a durable, long-wearing construction was needed. The gold toe provided extra reinforcement.

This 1930s factory view shows several loopers at work. The looping machine would actually sew up a stocking's toe area by spinning the stocking on a cylindrical wheel while the worker arranged the sock on the individual needles. The machines moved at a rapid pace, and demanded expertise by the operators to keep up with the momentum. Completed stockings would be removed from the machine, and then taken to an inspection area to be checked for flaws.

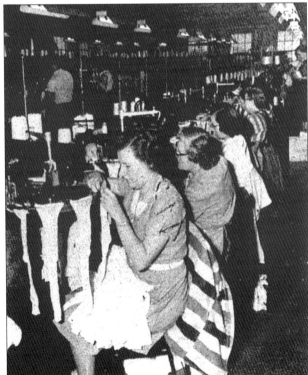

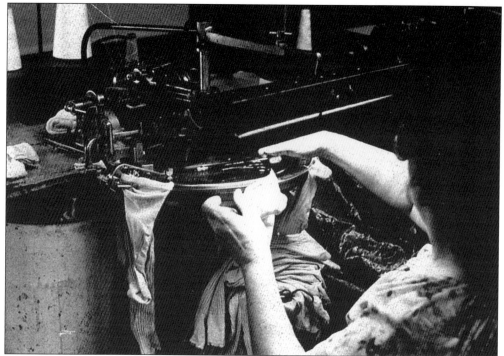

In the mid-1900s, many women in the community were "home workers." Great American was one of the companies that helped women bring extra money to the family. The income was meager, but the job allowed women to continue to raise children at home. Pay was based on what was referred to as "piece work." A worker received a certain amount for 24 stockings. A driver from Great American would deliver bags of stockings to be sewn and, after a few days, pick up the finished ones. This was a weekly event. The home worker trade ended years later.

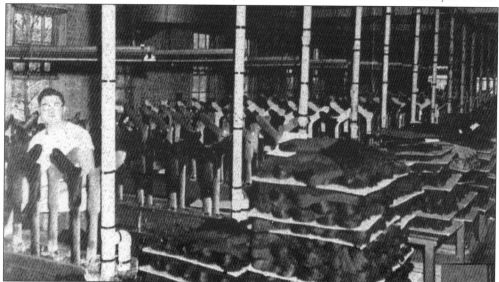

In this area of the Great American plant, stockings were placed on forms to check for defects. If any were found, the stockings were repaired and placed aside as "seconds." This photograph was taken in the 1930s.

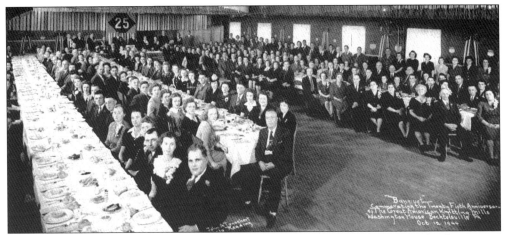

On October 12, 1944, Great American commemorated its 25th anniversary with a banquet at the Washington House, on Route 100 in Bechtelsville. A memorial plaque was dedicated in tribute to those employees who died during the years of the firm's activity. The plaque was dedicated by Rev. Aloysius Sherf, rector of the Most Blessed Sacrament Church in Bally. The memorial was unveiled by Mary Benfield of Bally, whose son was one of the firm's 18 employees then serving in the armed forces, and Jennie Fronheiser of Bechtelsville, whose two sons were also serving in the war. Both Mrs. Benfield and Mrs. Fronheiser were original employees of the firm.

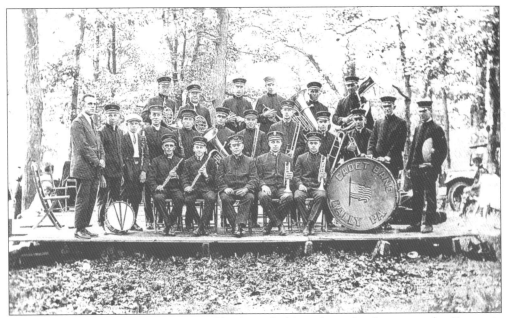

The Cadet Band of Bally was organized by Isaac Stahl, and was first known as the Germania Band of Bally. During World War I, the name was changed to the Cadet Band. Isaac was not only a conductor and a trombone player, but also a writer of several stirring marches during World War I, several of which he had copyrighted.

This baseball team dates back to *c.* 1935, and the players were members of the Catholic church. The photograph was taken in the field by the church path. Bally's Sixth Street ended near the Benfield family homestead, and there began the famous "church path" that was used by locals to walk to the church, school, and cemetery.

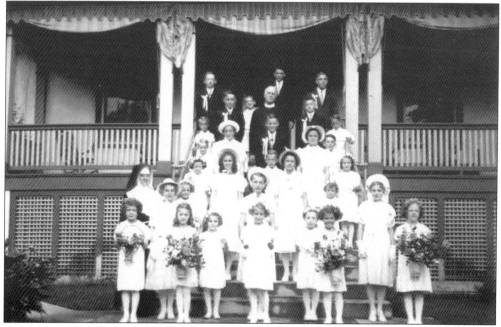

A class from the Catholic old school appears on the steps of what was known as the Convent, the home of the Sisters of St. Francis. This photograph was taken during the summer of 1934, when the school was celebrating the eighth-grade graduation. At this time, students were still taught in one-room schoolhouses.

The very first post office building in Bally was located on South Sixth Street behind the First National Bank of Bally (now Longacre Electric). The small structure was later moved to Forgedale, and was modified to serve as a private residence.

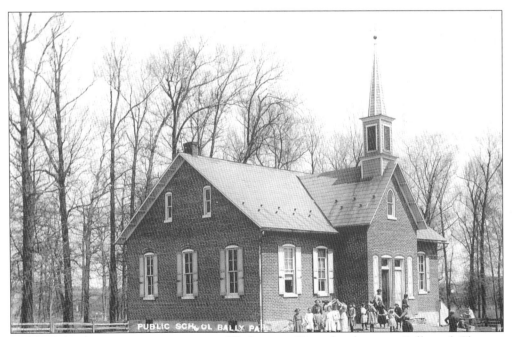

Diehl's School was a stone structure in Washington Township between Bally and Clayton, built in 1850 and in use to the beginning of the 20th century. The remnants of the building were removed in 1921, a year before the present Route 100 was straightened out from its former path of passing between two barns on one side and a farmhouse on the other.

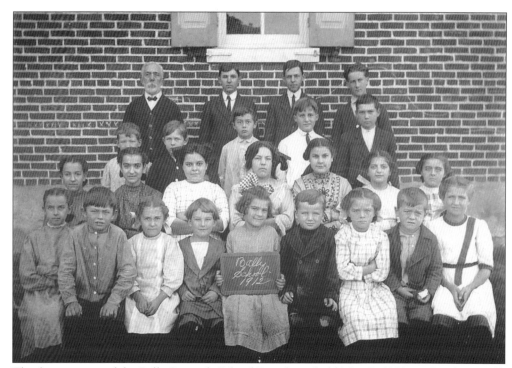

The first meeting of the Bally Borough School Board was held May 7, 1913, in Quigley's Hall. The following officers were elected: president, Nicholas Melcher; vice president, Harvey Stengel; secretary, O. W. Berkey; treasurer, U. L. Moyer; and member, James Melcher. At this time, 84 children of school age lived in the borough; 22 of them desired public school. On June 9, 1913, the school board rented a building from Washington Township that was known as Diehl's School. On June 16, 1913, the first schoolteacher, May Steyer, was hired and paid the minimum legal salary of $50 per month.

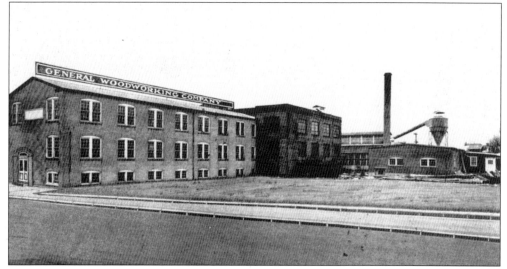

Seen in this photograph of the General Woodworking Company (later Bally Block Company) are, from left to right, the finishing and storage buildings, the power and heating plant, and a portion of the mill and machine building.

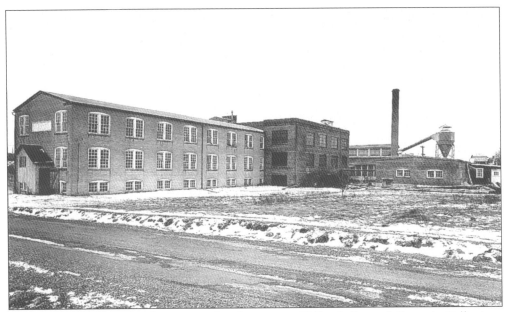

The Bally Block Company has occupied its location at 30 South Seventh Street in Bally since 1929. The original building, which still stands, dates back to near the turn of the 20th century. The building has been used as a woodworking facility since *c*. 1920.

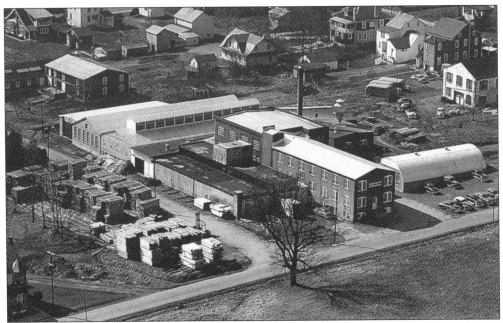

Various expansions of the General Woodworking (later Bally Block) buildings were made over the years to accommodate increased business volume. With reorganization in 1929 and establishment of the name "Bally Block Company," the firm began to manufacture meat-cutting butcher blocks.

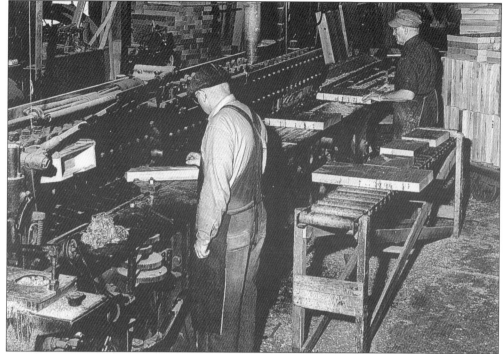

At the Bally Block Company, many steps in manufacturing are involved, including measuring, sanding, and inspecting each piece of wood used. Original products include such varied items as caskets, cedar chests, and radio cabinets.

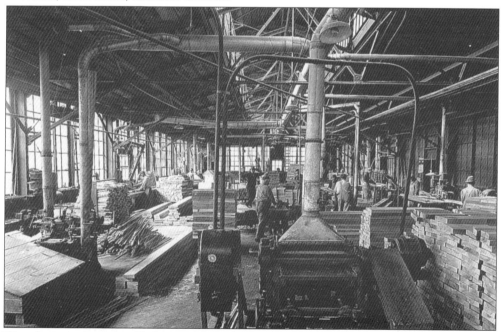

The planing operation added a smooth surface to the counter-top block. In the planing area today, technology has advanced since this original process. Workers now use an abrasive planer—a high-powered sander—for a much finer finish.

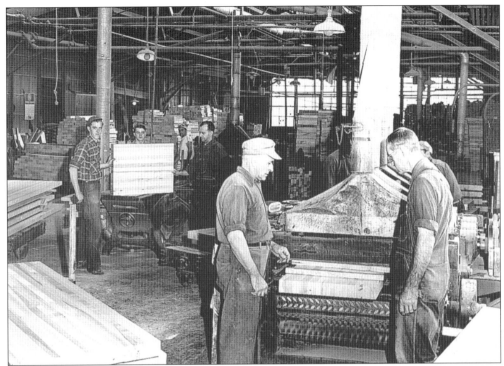

Bally Block Company employees prepare to transport heavy sections of wood blocks to the next staging area. This view gives an idea of the finished product, whether it be a large cutting table or a small block for cutting or chopping.

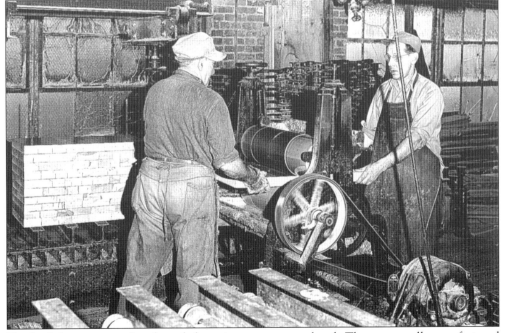

To the left, compressed and sanded sections are accumulated. These were all manufactured through cutting and gluing together various woods to fill the increased demand of orders.

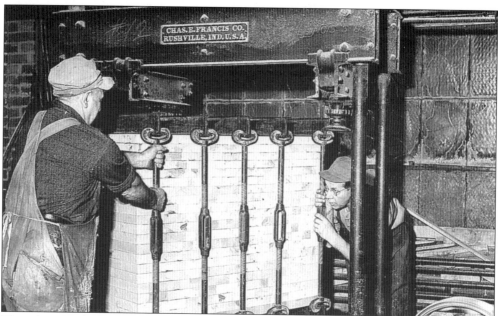

This photograph depicts the clamping operations at the Bally Block Company, during the process for manufacturing meat-cutter's chopping blocks (butcher's blocks). Generally, the clamps stayed on overnight to allow the glue to dry. The next day, the clamps were removed and all surfaces were planed smooth. Large holes were drilled before proceeding to the next stage, shown in the below photograph.

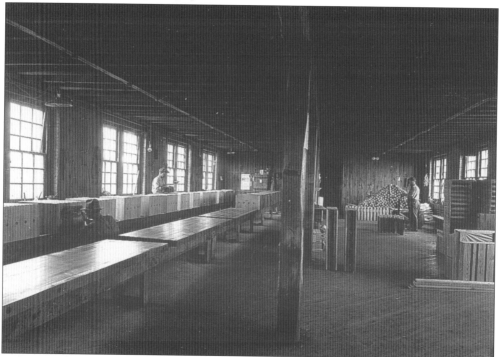

In this area, the blocks were inspected and their edges were beveled. Any necessary repairs were done here. Next, the blocks were finished with oil and packaged in cardboard for shipping.

Bally products are manufactured with the highest standards of quality in the Pennsylvania Dutch tradition and are shipped all over the world. The butcher's meat-cutting blocks can be found in a great number of grocery stores, and some facilities use early models of the cutting blocks.

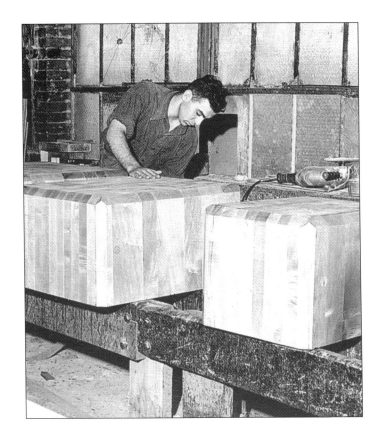

Please present this bill at time of payment

Barto Post Office

BALLY BOROUGH ELECTRIC, Dr.

RATES:
15c per K. W. for first 10 K. W.
10c per K. W. for second 10 K. W
8c per K. W for third 10 K. W.
6c per K. W for all over 30
K. W. used in one month.
Motor rates, 3 H. P. and over
6c per K. W.

Electric Light
- Meter at this reading....................
- Meter at last reading.....................
- To consumption of...........K. W. $..........

Electric Power
- Meter at this reading.....................
- Meter at last reading......................
- To consumption of................K. W. $........

Total for this month $....................

Received payment for the Co.

By....................

To bill or bills rendered $

Date................ 192

Total $

Should the supply of light fail from any cause natural or accidental, or should any injury result in any way to persons or property in the use or handling of the light, the Borough Council shall not be held responsible for such resulting failure or accident. All bills payable on or before the 10th for each month. 20 per cent advance on above prices

This original Bally Electric Company bill dates back to 1925.

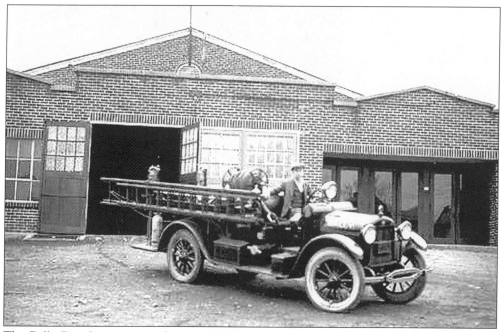

The Bally Fire Company was born in 1923 after a destructive fire at a local industrial mill showed a dire need for a local fire company. In this 1920s photograph, the fire truck is a 1927 Reo, which pumped 300 gallons per minute. It was Goodwill's second or third vehicle. Seated in the truck is Chief Warren Benfield.

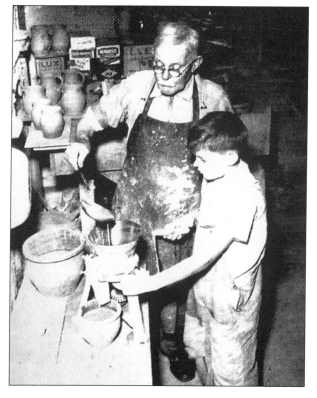

Charles Stahl, born in 1828, started serving his apprenticeship in the pottery business at age 15. He died in 1896 after working at the craft for 53 years. Isaac Stahl, the man pictured here, was born on September 15, 1872, and was the last of the old-time hand potters in the area. From early youth to three years before his death, Isaac devoted his evenings to music. He organized the Germania Band of Bally (Cadet Band), serving as conductor for 25 years. Isaac also aided in the development of the Bally Fire Company, of which he became a trustee and member of the house committee. He died in 1942.

Today, Stahl pottery is a collectible. The Stahls dug their own clay for use in the pottery.

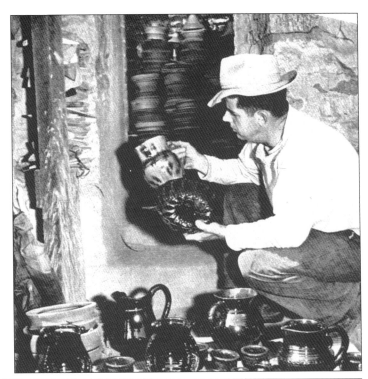

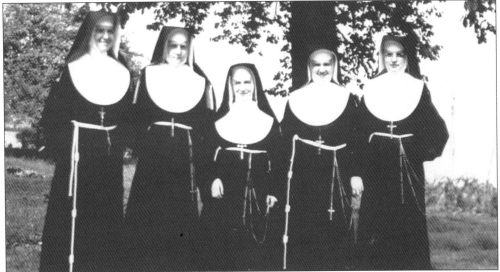

The first religious community to teach at Bally, in 1889, were the Sisters of St. Francis from Glen Riddle. Three sisters were assigned to Bally: Sister Mary Agatha, superior; Sister Mary Cordula; and Sister Mary Finton. Their first home was the residence between the church and the priest's house, where Father Bally had lived. The sisters shown here taught at the Catholic school during the mid-1900s. Pictured in the middle (the shortest) is Sister Theonilla, a legend in the school. She taught many members of the same family, ranging from the mother and father down to the youngest children. Another is Sister Crispin (not shown), who took over classes in 1946. In addition to teaching first and second grades, Sister Crispin prepared the second-graders for their First Communion.

43

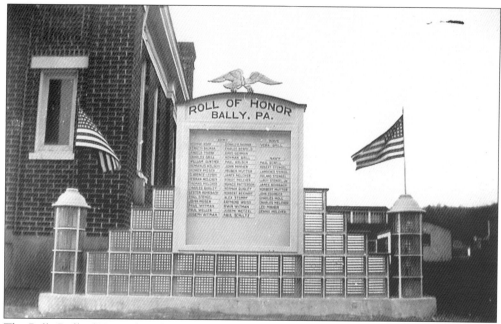

The Bally Roll of Honor listed all of the town's men who fought in World War II. Each town had its own Honor Roll as a tribute to its courageous men.

The Bally Roll of Honor was constructed next to the town hall for all to see and to commemorate our men.

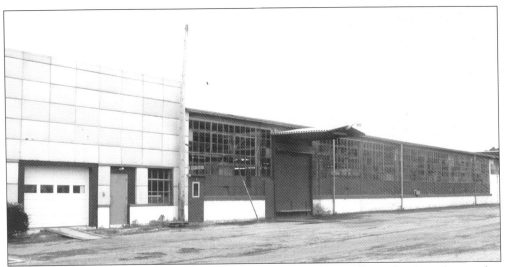

Leonard Melcher, a native of Bally, was the sole proprietor of a small woodworking factory that manufactured radio cabinets in the early 1920s. In 1931 he made the transition to manufacture meat display cases. In 1934, Melcher and George Prince of Pottstown formed a partnership and adopted the name Bally Case & Cooler Company for their business. In 1942, Prince's brother, Leon, joined the partnership to be in charge of sales. And in 1946, George Melcher, Leonard's brother, joined the company to take complete charge of design and engineering. Bally Case & Cooler eventually became the world's largest manufacturer of walk-in coolers and freezers.

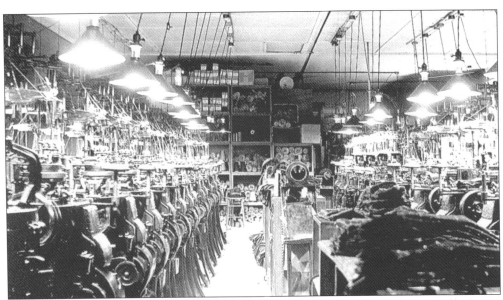

Gehman Knitting, owned by Enos Gehman, was one of several knitting mills in Bally. It was located on a dirt lane off Main Street. As shown here, rows of knitting machines lined the building. Spools of various threads were used; employees had to continuously keep watch in order to refill the spools. One person could be responsible for overseeing one or two rows of knitting machines at one time.

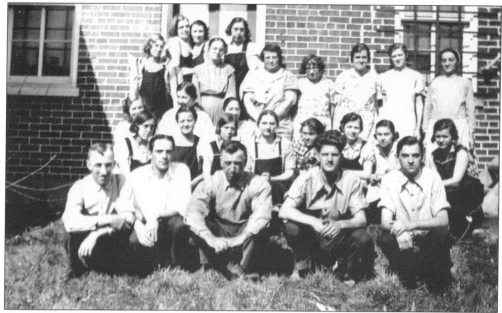

These 26 hardworking employees at Gehman Knitting were all local residents, and many were Gehman family members.

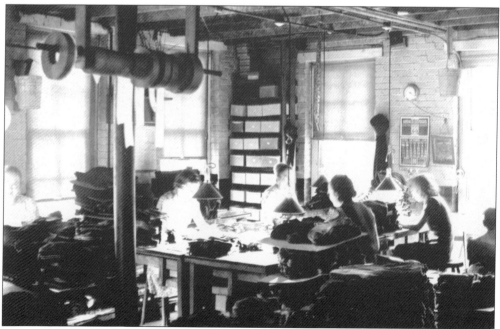

Women sort and repair stockings.

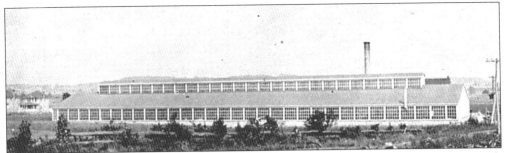

The Bally Ribbon Mill, also referred to as the Silk Mill for many years, was located on Seventh Street. Founded in 1923, the company made woven textile products that were required by manufacturing concerns throughout the country. The present buildings stand where the former Orono Silk Ribbon Mill was erected in 1907 by George W. Melcher. Orono Silk operated until 1920, when it was sold to the Queen City Silk Company of Allentown. On January 11, 1922, a fire completely destroyed the plant of Queen City Silk.

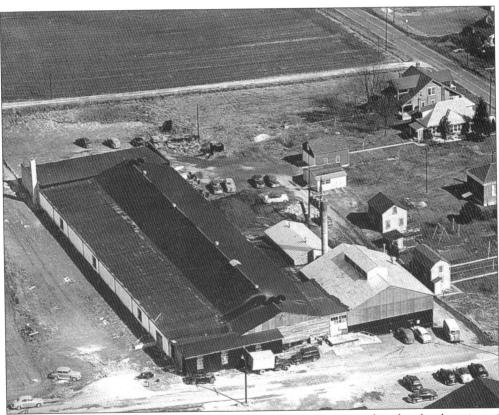

On May 31, 1923, the Bally Ribbon Mill corporation was organized under the direction of Herbert D. Harries. After the tragic death of Harries in a plane crash, the mill continued its operation under the leadership of Harries family descendants. This aerial view of the mill shows various expansions. The town hall was later purchased by the company, allowing for additional expansion. The Bally Ribbon Mill now covers an entire block along Seventh to Eighth Streets and Main.

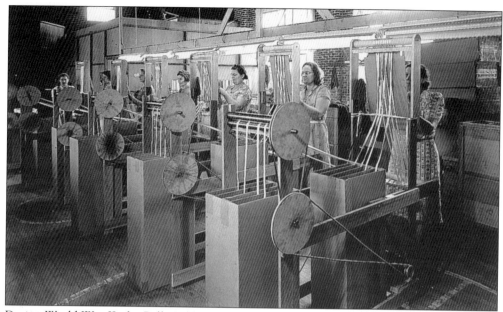

During World War II, the Bally Ribbon Mill used the back section of the Bally Fire Company for some of its manufacturing process. The company then expanded its product line due to increased requirement in the military, industrial, and civilian fields.

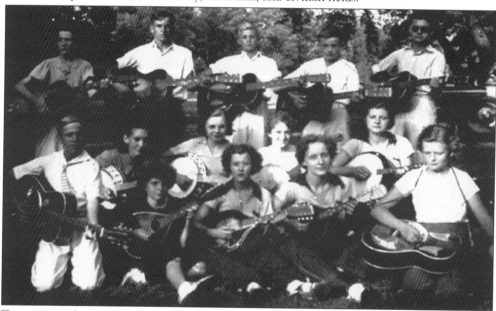

Teenagers and young adults from the Bally area comprised this local band. They took music instructions from a Mr. Groff and played at hoedowns and other events, traveling as far as Zionsville. Pictured in the front row, center, is Helen (Benfield) Stompf, the author's mother, who played the mandolin. To her right is Regina (Reichert) Benfield, the author's aunt, who also played the mandolin, accordion, and piano. In the back row, second from the left and playing guitar, is Charlie Benfield, the author's uncle. Charlie attached a harmonica to his guitar and actually played both instruments at one time, which delighted many. Fourth from the left in the back row is Norbert Reichert, who also played the guitar.

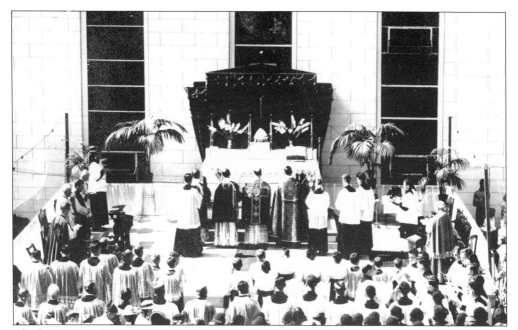

The bicentennial celebration of the founding of the Most Blessed Sacrament Church in Bally was marked with a Solemn Mass on August 3, 1941. A triple program was carried out, beginning with the outdoor Mass in the morning, Solemn Vespers in the afternoon, and a band concert in the evening.

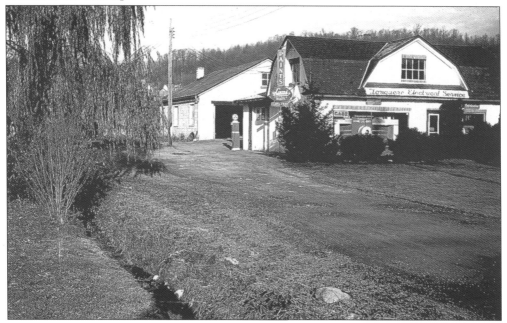

In 1922, Arland E. Longacre, a farm boy, started Longacre Electric while doing electrical work in a shed on the family farm near Bally. One of Longacre's earliest store buildings was constructed in 1934 on the corner of Fifth and Main. The building was later leased to the Wright family for Wright's Restaurant and, since then, has continued to be used as a restaurant facility by various owners.

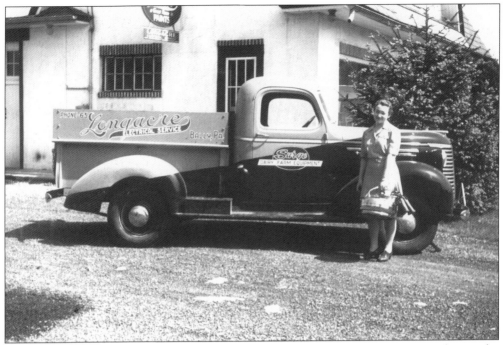

This photograph, depicting one of the first trucks used by Longacre Electric, was taken at the Fifth and Main store.

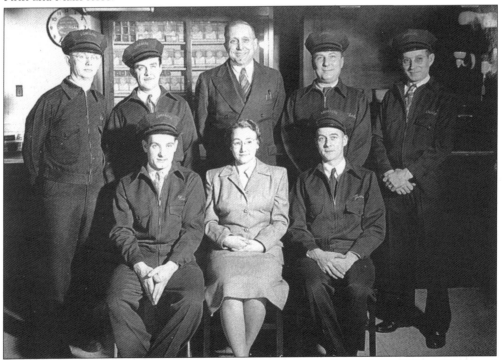

The first employees and owner of Longacre Electric are, from left to right, as follows: (first row) Russell Weller, Edna Longacre, and Jim Gerhart; (second row) Irvin Gehman, Ray Wiend, Arland Longacre (founder and president), Charles Specht, and Kirlin Moyer.

At the time of this photograph, Longacre Electric's central store and offices were located in the former First National Bank of Bally building. Extensive renovations were made in later years, as well as expansions to fit the company's growing needs.

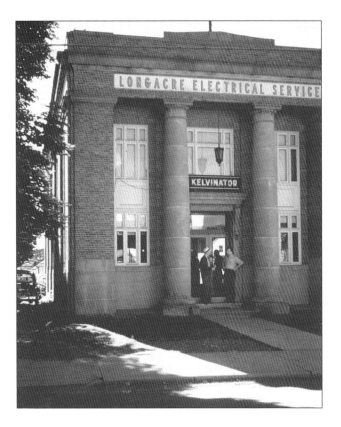

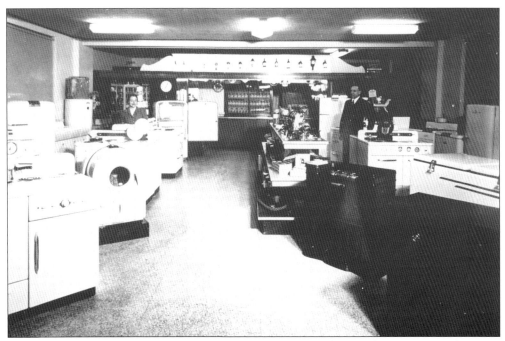

The showroom area of Longacre Electric included all types of appliances, from ranges to televisions.

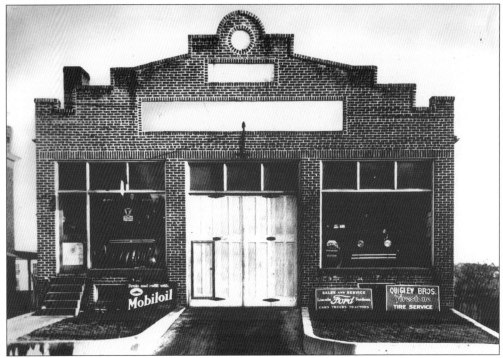

Quigley Brothers Ford, owned by Joseph S. and William S. Quigley, was located on Main Street in Bally. Note the Ford Model T in the showroom window.

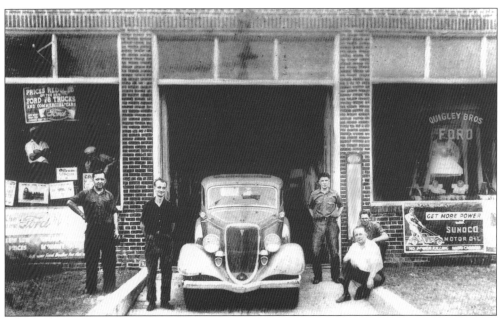

In this photograph of Quigley Brothers Ford, William S. Quigley is on the left, while his brother James kneels in the back right. Harold Mutter stands on the right. The vehicle is a 1934 Ford Model 40 V8. The building exists today as the Bertoia Studio.

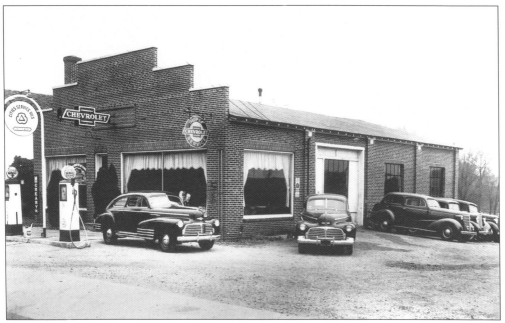

In 1935 James S. Quigley, brother of Joseph and William Quigley, along with Charles H. Moll opened a garage at 326 Main Street. In 1941 it became known as James S. Quigley Chevrolet. Pictured are new 1941 model Chevrolets.

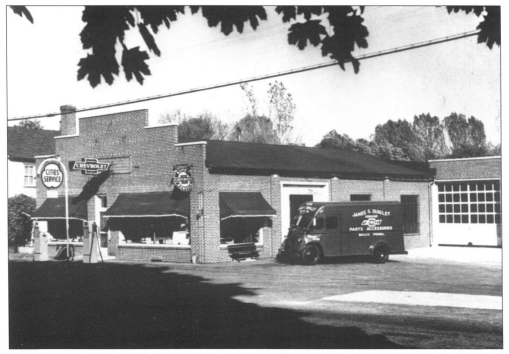

James S. Quigley Chevrolet, on Main Street in Bally, appears here in 1948. The Chevrolet Step-Van was used for parts sales to area garages and farms.

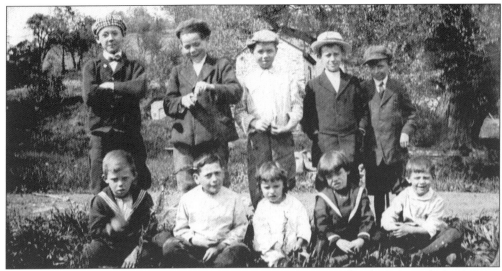

The Boys from Barto Road in 1912—or should we call them "The Little Rascals from Barto Road"? From left to right are the following: (first row) Gerald Stahl, Norman Bauer, Russell Stahl, Clarence Stahl, and Joe Stahl; (second row) Leo Fox, Tony Bauer, Francis Stahl, Newman Stengel, and Norman Schell.

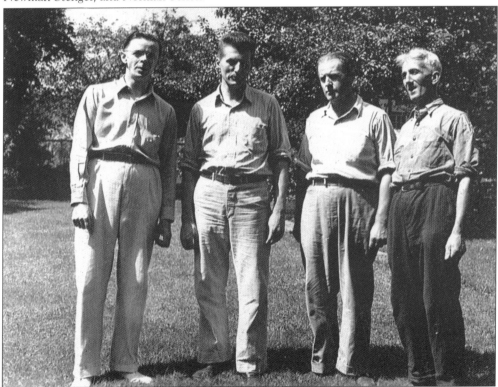

Original members of the Attaboy Quartet included, from left to right, Edgar Kulp, Russell Bechtel, John Simmons, and Ralph Berky. The group gained popularity in the 1920s. Ralph Berky, representing the uniqueness of the Bally community, started Larkland, which he referred to as "a shrine for lovers of nature and beauty."

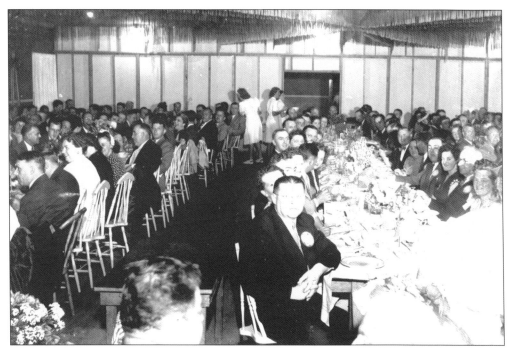

The Charter Night Banquet for the Bally Lions Club was held in July 1946 at the Washington House, on Route 100 in Bechtelsville. The original charter carried the names of 30 men. The Lions Club has been valuable to the community throughout the years by helping the needy and assisting in local affairs.

Peter Boyle once lived in the nearby Bally area. He regularly attended church services on Sundays at the Most Blessed Sacrament Church. Many remember him as "Uncle Pete," who appeared on a Philadelphia TV show when televisions first came out. His son, also named Peter Boyle, once dedicated his life to being a monk, but is now a famous television and movie personality.

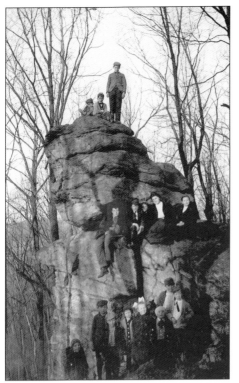

On a beautiful spring day, it was fun to take a climb along Crow Hill toward Forgedale. The primary goal was to reach the top, where a large Native American rock stands and one can view the landscape for miles around. This area also housed the residence of Patrick Giagnocavo. Many could not say his name, so they called him Pat Janocky. Children would watch for Pat to come down Crow Hill on his horse and buggy. Converting to the brotherhood and faith of Menno Simons, he dressed in his Sunday black-and-white collar to bring him to the simple life.

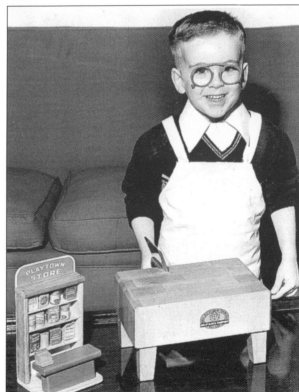

This little boy was featured in advertisements for butcher blocks. Note the cutting block's miniature size.

Two
BARTO

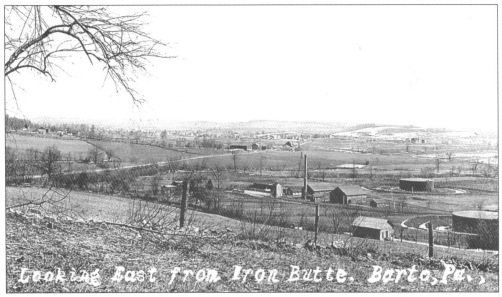

Looking east over the Washington Township countryside, one could see the vast amount of farmland in this Berks County area. This photograph was taken from a hill then known as "Iron Butte."

Traveling in the early 1900s from the Schultzville area to Barto, one viewed the dirt lane, with the Barto Hotel on the left and the railroad depot on the right. The town was named after Abram H. Barto, born on March 4, 1855. He inherited his father's farm, which became valuable with the building of the Colebrookdale branch of the Philadelphia & Reading Railroad. The railroad depot was built near the western border of the farm. The depot and the village were first named Mount Pleasant (after the Mount Pleasant Furnace that was located in the area until 1875) but were later renamed as Barto.

The late 1800s saw quite an evolution in the little village of Barto. The Barto Hotel was built c. 1880, and the first proprietor was John Baus, pictured here in 1908 with his child on the horse and buggy. The hotel offered rooms for train travelers and catered to the men of the community, who ate their meals and had their laundry done there.

Many travelers on the railroad booked rooms at the Barto Hotel during their visit for business or pleasure. This photograph depicts the hotel in the late 1800s. The hotel, passing through many owners during the years, has amazingly been historically preserved. Today, resembling the original building, it still serves as a hotel, bar, and restaurant where local folk congregate.

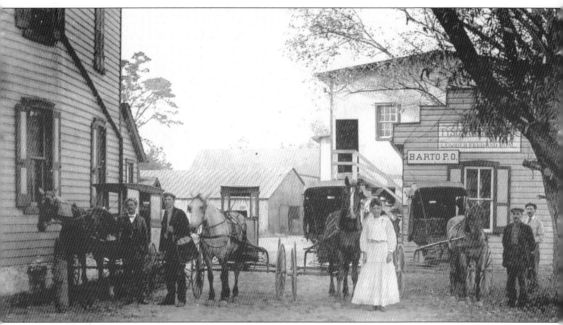

The Barto Post Office, seen here in 1908, was located in the frame building on the right. To the left, next to the Barto Hotel, are wagons that were used to deliver the mail to Barto's two rural routes. Elva Reed, seen here in the white dress, was the Barto postmaster from 1920 to 1962.

Barto's first post office was established on March 16, 1882, and was originally housed in the Barto General Store, operated at the time by Benjamin Sell. Later, Harold Fluck ran the store.

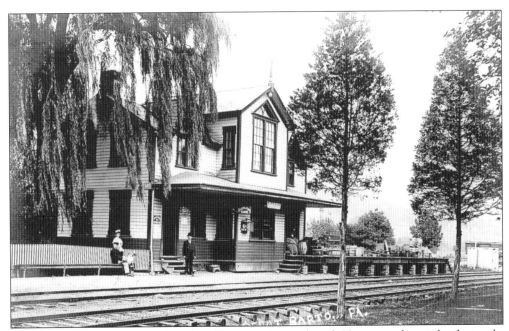

The railroad station was very busy handling travelers and mail. Here, travelers sit by the tracks while awaiting their transportation to whatever the destination. From Barto, the train traveled through Bechtelsville to Boyertown.

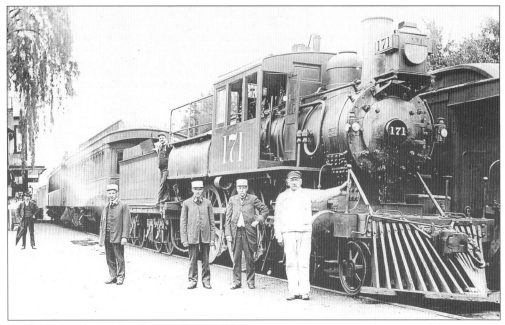

At the Barto depot, the first mail arrived by train at 6:30 a.m. Another train delivered mail again at noon, and picked up outgoing mail around 1 p.m. The last shipment arrived around 5 p.m., with the train again picking up outgoing mail at 6 p.m.

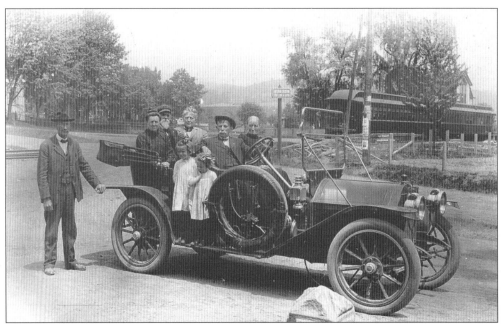

John Baus and local residents take a drive in his motorized vehicle. In the background, the hotel appears on the left and a train leaves the railroad depot on the right.

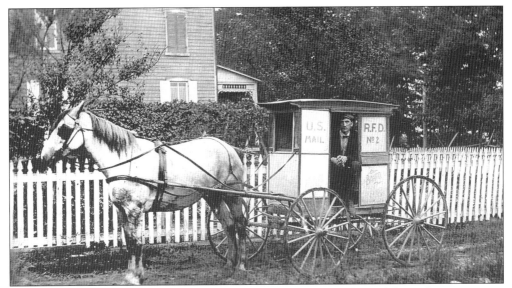

Today, when opening their mail, people do not think of how mail was delivered centuries ago. The U.S. mail was delivered to rural routes by a mail carrier on horse and buggy. Francis Walters served as Barto mail carrier from 1905 to 1930. Joseph Walters succeeded his father, taking over Rural Route 2. Howard Fluck was added as mail carrier for Rural Route 1.

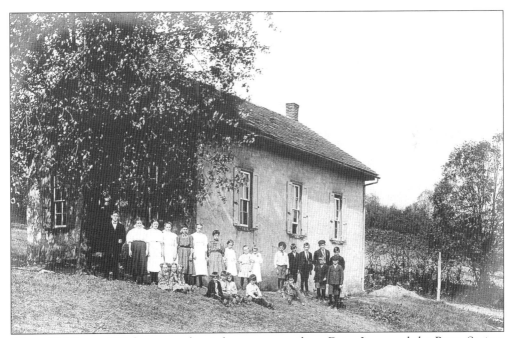

Along Old Route 100, between what is known currently as Dairy Lane and the Barto Spring, the first Barto school was located. The second school (shown here) was situated further past the Barto Bridge, approaching the village. This building is still on the site, and has been retrofitted into a family home.

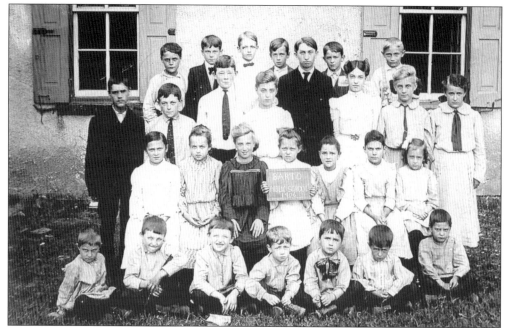

Elva (Gruber) Reed is among the students in this photograph taken at the second school in Barto. Reed later became the village's postmaster. Barto's one-room schoolhouse was closed in 1952.

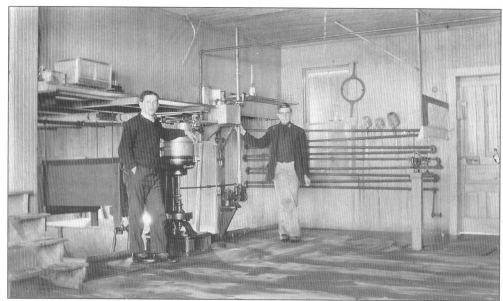

Robert Kemmerer bought the Barto Creamery from Harbison's Dairy of Philadelphia and managed it from 1912 until 1929. The creamery was not a place where cheese and butter were made, but a "milk station." The site was actually used to collect fresh raw milk from local dairy farmers. The same day the farmers delivered to the station, the milk was transferred to large cans and stored in a room for cooling by an ice machine.

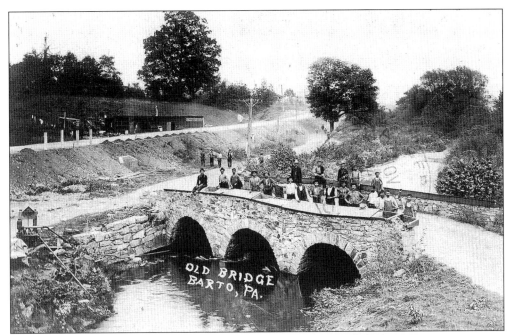

The third Barto bridge was erected in 1908, and is shown here. While the pumping station was being built, road crews were constructing the bridge. The Barto bridge continues to be heavily traveled, on what is now referred to as Old Route 100, the first state road in eastern Berks County. The first bridge was erected in 1797, and the second Barto bridge in 1847.

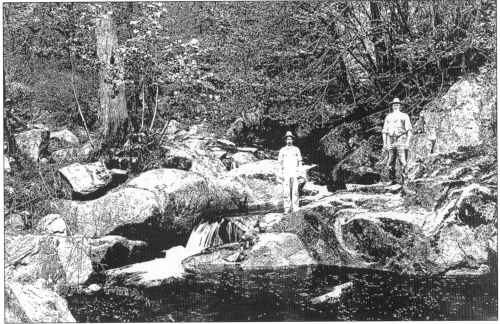

Over the centuries, this site has been well known to residents of all ages. Called "the Rocks," it is a place where a rocky stream varies in depth as it flows down the road toward Barto. In the heat of the summer, it was an area where locals would go to cool off and take a swim prior to the advent of swimming pools. The location still exists, to the pleasure of many.

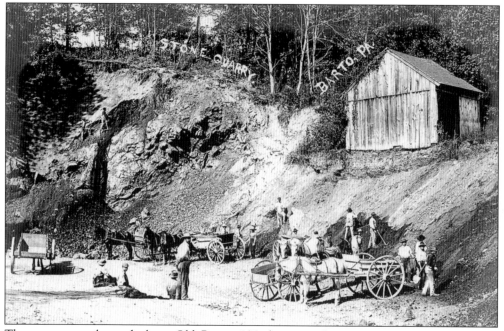

The quarry was located along Old Route 100, between the one-room Barto School and Forgedale Road. Owned and operated by R. Etta Barr of Allentown, the quarry closed c. 1930, and the private railroad tracks were removed.

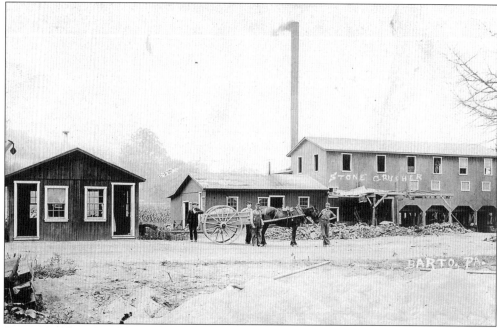

Stone was blasted and loaded into small cars down in the quarry area. The stone was pulled along tracks to the crusher at the top of the hill, where many large pieces were still crushed by laborers. From the crusher, the stone was loaded into railroad cars on the private siding of the Reading Company. The engine "backed" from the Barto station up the private railroad track, and from there the carloads left to travel to their destination.

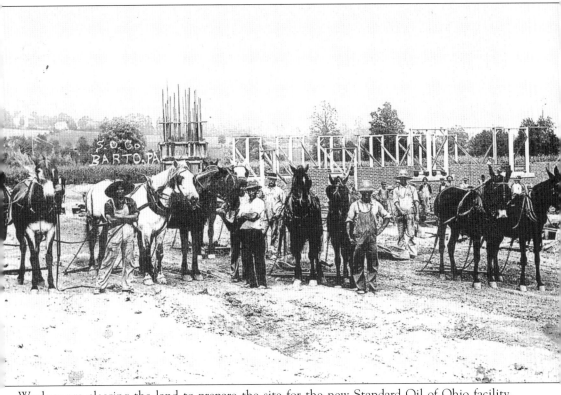

Workers are clearing the land to prepare the site for the new Standard Oil of Ohio facility. There was no heavy equipment at that time, so mules were used to pull and transport heavy trees and building materials.

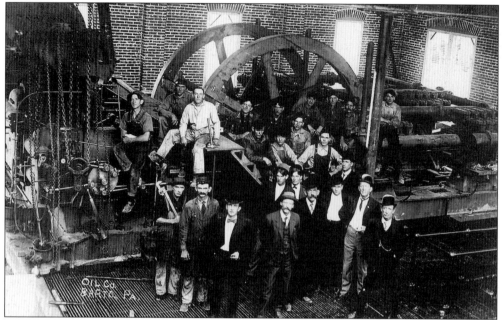

When the pumping station was first built in 1908 on a 20-acre lot, it was part of Standard Oil of Ohio. In later years, it sent gas supplies and was known as the Tuscarora Pipeline Company's Barto Station. Here, employees appear in front of the pumping wheel in the pump house.

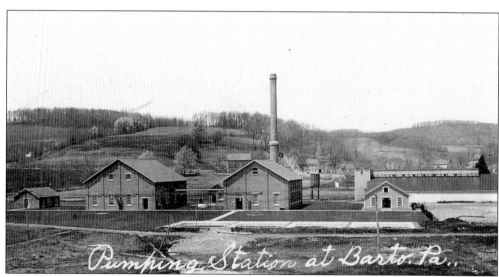

The pumping station was part of a string of relay facilities that moved crude oil from western Pennsylvania to New York state. The station was in operation from 1908 to c. 1950. From left to right, the buildings shown are the pump house, the powerhouse, and the tool house. The long coal-storage building was located behind these three structures.

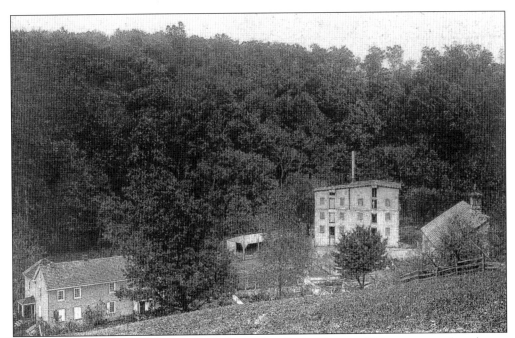

In the valley was one of the many mills located in Berks County. This one was referred to as Saylor's Mill. Further up Forgedale Road, Anthony's Mill was purchased by that family in 1830 from the Steltz estate. The road that branches off Forgedale Road is now called Anthony's Mill Road.

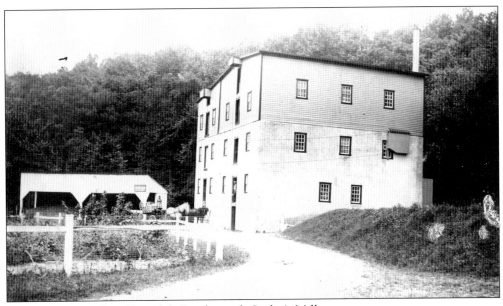

This closer view along Forgedale Road reveals Saylor's Mill.

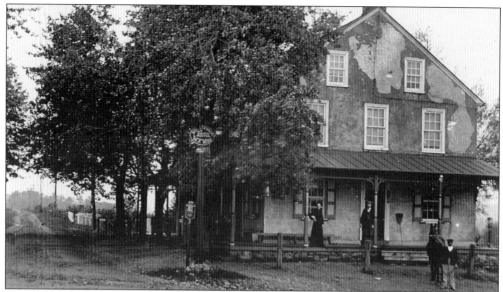

This building was situated on the corner at Schultzville. The highly traveled dirt road on the left is now Route 100. The dirt lane in the foreground led to Barto.

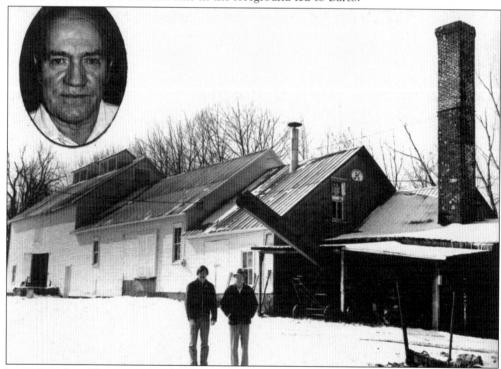

In 1930 Robert Kemmerer purchased the former Barto Creamery property and established his business at the location (shown here). The Kemmerers have been extracting birch oil since 1933. Around 1946, Kermit V. Kemmerer (inset) joined his father in the distilling business. Kermit's son, Larry, later joined in the operations. In the foreground here, Larry (left) and Kermit stand outside the Kemmerer distillery. Of special note, Larry Kemmerer has so graciously provided many of the images in this book.

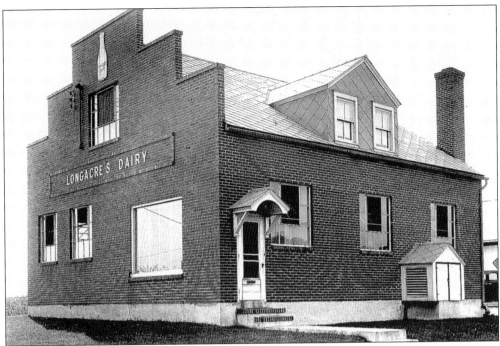

Longacre's Dairy was started on the original Longacre family dairy farm along Route 100. At the farm, fresh whole milk was poured into large kettles. Due to the increase in demand, the first commercial dairy building (pictured here) was constructed up the road from the family. The building was expanded several times throughout the years.

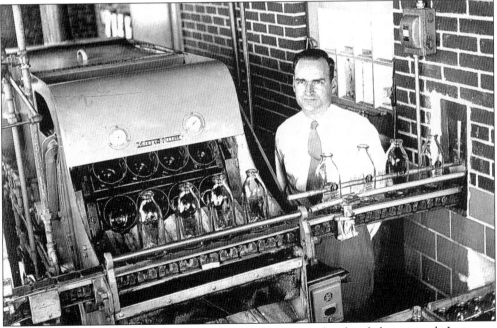

Daniel Longacre assumed control of the dairy business after his father retired. Longacre Dairy, known all over the area for its milk and homemade ice cream, is still operated by the Longacre family.

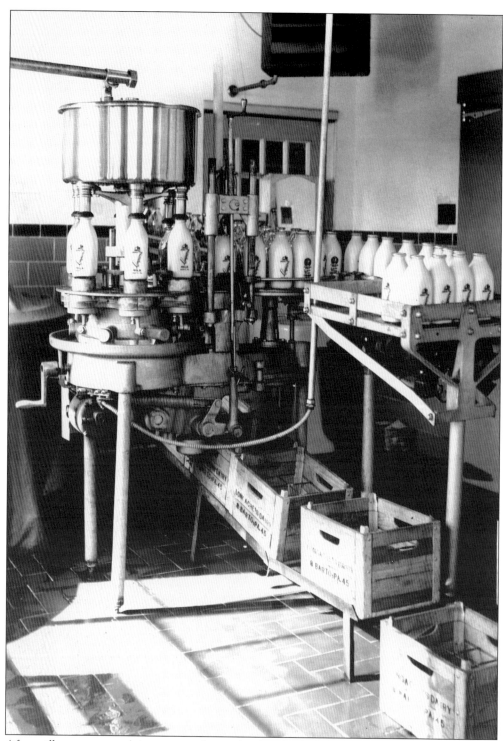

After milk was processed, it was poured into glass bottles for home delivery with the help of this equipment. Local residents relied on the milkman stopping by at least twice a week to deliver fresh milk and butter.

Three

BECHTELSVILLE

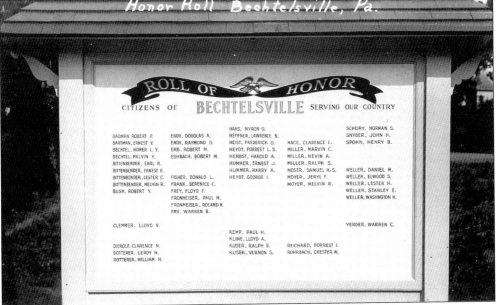

Bechtelsville erected this Roll of Honor to pay tribute to its men fighting in World War II.

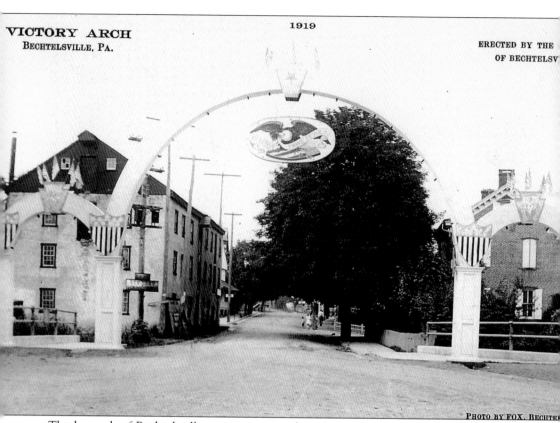

PHOTO BY FOX. BECHTE

The borough of Bechtelsville was incorporated on September 11, 1890. The boundary lines included 194 acres. The territory, taken from Washington Township, is situated along the Colebrookdale branch of the Philadelphia & Reading Railroad, three miles beyond Boyertown. The borough was named after John S. Bechtel, son of local farmer and miller Isaac Bechtel. This victory arch was built in 1919 and was installed by the citizens of Bechtelsville after World War I.

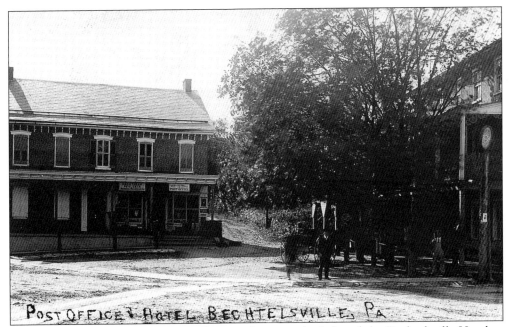

POST OFFICE & HOTEL BECHTELSVILLE, PA.

The Bechtelsville Store and Post Office are shown to the left and the Bechtelsville Hotel to the right. During Thomas Edison's visit to the area while building his iron ore plant, he roomed at the hotel. Edison was not sociable and went out of his way to avoid mingling with local folk. He closed his plant in a year's time since it did not supply the quantities of iron ore needed for his project.

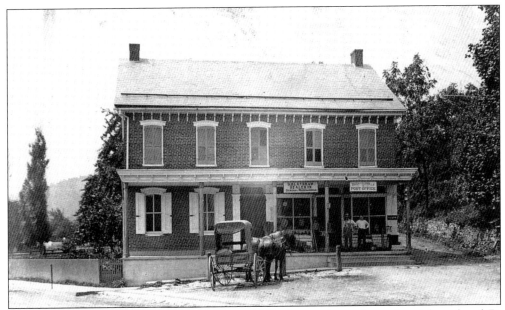

The post office opened in Bechtelsville in 1852. It was located on the right side of D. Latshaw's store, a dealer in "General Merchandise" (as shown on the sign), which meant he was the local grocer.

75

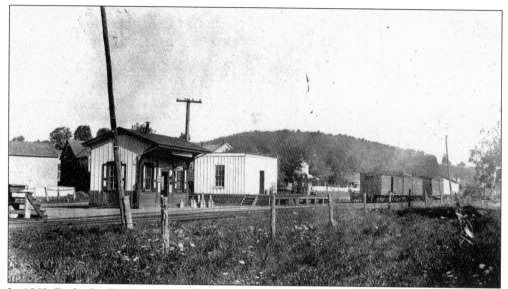

In 1868, Bechtelsville became another stop for the Colebrookdale branch of the railroad. This was the original Bechtelsville depot. Railroad stations were used heavily due to lack of transportation in the community. Also, orders of merchandise were delivered via the trains to the closest depot for pickup by customers.

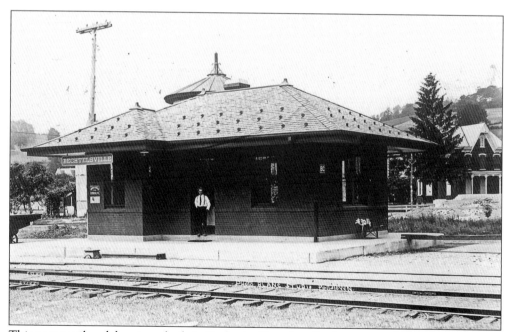

This newer railroad depot was built in Bechtelsville to handle the increased volume of business.

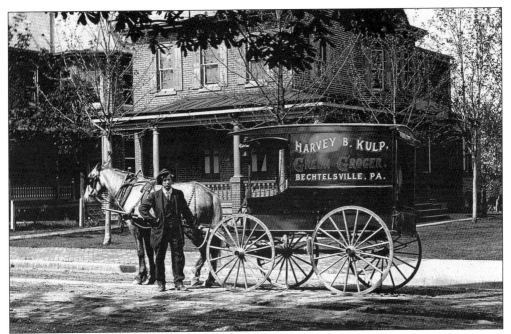

Every town needed what was referred to as a green grocer or "huckster." Harvey B. Kulp, as the local grocer, delivered fresh produce to the homes in the area.

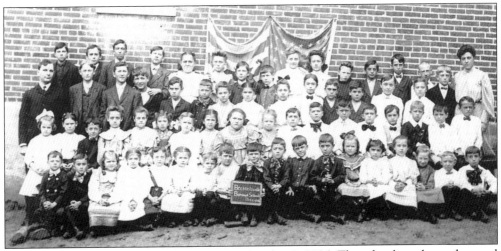

The 1906 Bechtelsville School class poses on October 2, 1906. The school was located several blocks from the store and post office.

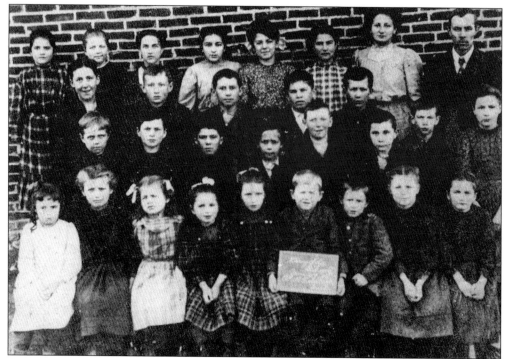

On June 9, 1894, the construction specifications for the Heydt's Schoolhouse were decided. By November 5, 1894, the new schoolhouse inspection had reported the building finished according to contract. The new Heydt's Schoolhouse was ready to instruct students in reading, writing, arithmetic, geography, and behavior. The students in 1912, along with teacher Aaron Rohrbach, are pictured here. The photograph includes the children of the Elam Benfield family: Charles, George, Warren, William, Henry, and Helen.

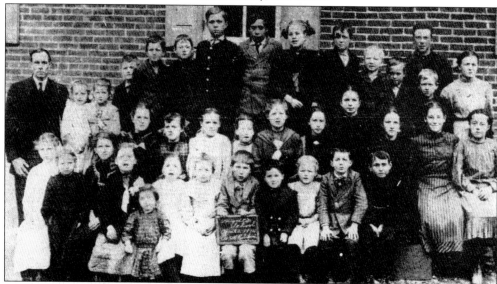

The Heydt's Schoolhouse students appear here in 1914 with their teacher Aaron Rohrbach. This area was known as Washington Township but carried a Bechtelsville mail code. The majority of the students spent their entire education in this one-room schoolhouse.

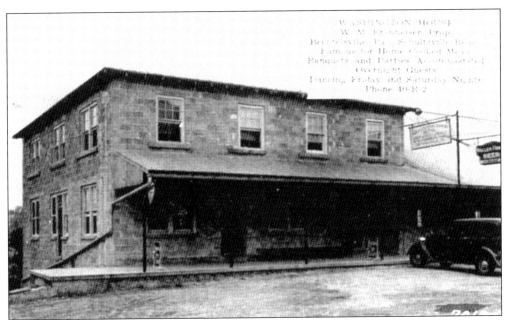

The Washington House, owned by W. M. Fronheiser, was located on the Schultzville Road (now Route 100) in Bechtelsville. A popular location for large banquets, anniversaries, and wedding receptions, the structure still stands and is used just as it was many years ago.

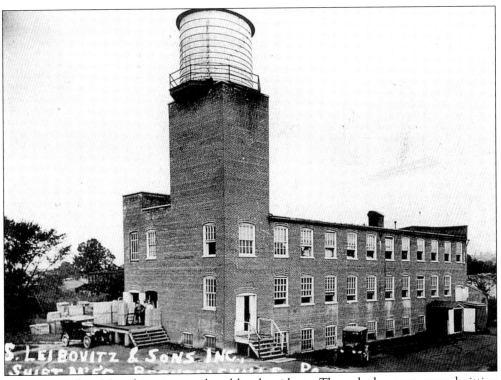

S. Leibovitz Shirt Manufacturing employed local residents. Through the years, many knitting mills have shut down their operations, Leibovitz included.

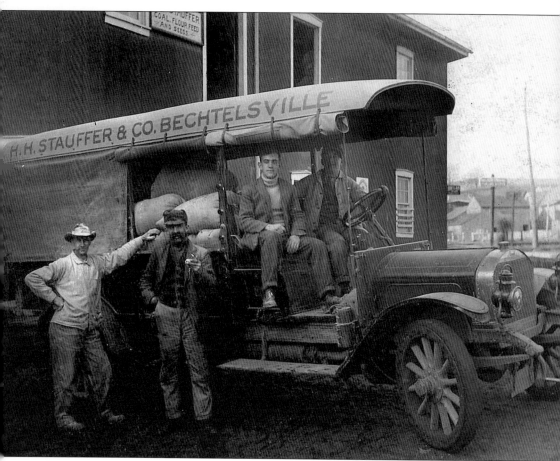

H. H. Stauffer and Company was a local mill that supplied coal, flour, feed, and seeds to the families and farmers in the area. Filled with large sacks of feed, this truck is ready to make a delivery.

Four
NEW BERLINVILLE

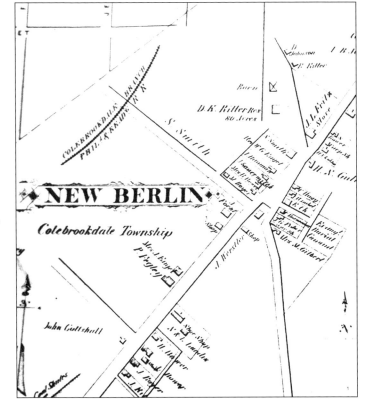

Shown here is a closeup map of New Berlin in Colebrookdale Township, prior to the name change to New Berlinville. The earliest post office was established in 1883 and was called New Berlin Station. On February 23, 1883, Jacob W. Leaver became the first postmaster. The first telephone was located in Jacob W. Leaver's store in 1881.

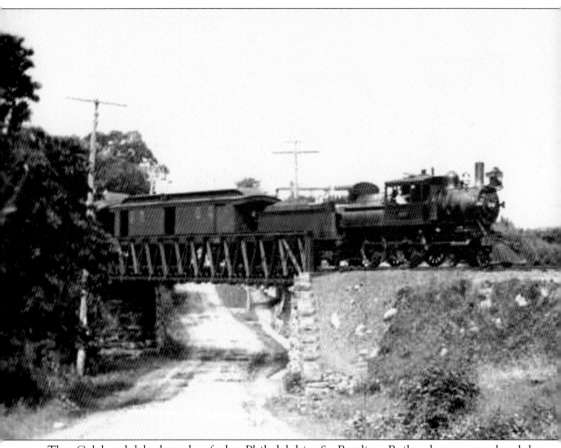

The Colebrookdale branch of the Philadelphia & Reading Railroad was completed by September 6, 1869, connecting Pottstown to Barto. In this photograph, the train passes on the tracks on North Reading Avenue, where Boyertown ends and the line starts for New Berlinville. New Berlinville was one of the several stops on the route.

Voting occurred at the New Berlinville Hotel and later at the schoolhouse. Residents reported that they voted four times for Franklin Delano Roosevelt, whom they considered "the Abe Lincoln of our time."

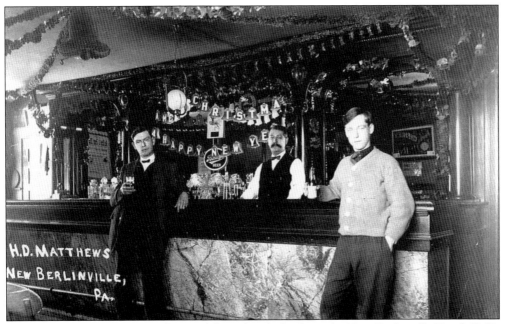

During the holidays, local residents celebrated with drinks at the New Berlinville Hotel. H. D. Matthews was the proprietor at the time

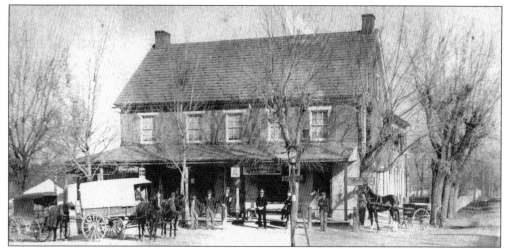

In 1881, Eurias Houck was the operator of an inn that was later named the New Berlinville Hotel. On February 23, 1883, in order to distinguish the area from New Berlin in Union County, the name of the village was changed to New Berlinville.

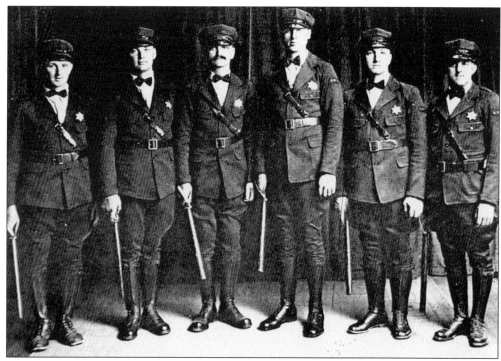

In 1930, the first Fire Police of New Berlinville was formed. Pictured from left to right are William Hartman, Paul Brintzenhoff, William Yoder, Lester Rothenberger, Frank Burns, and Willoughby Miller.

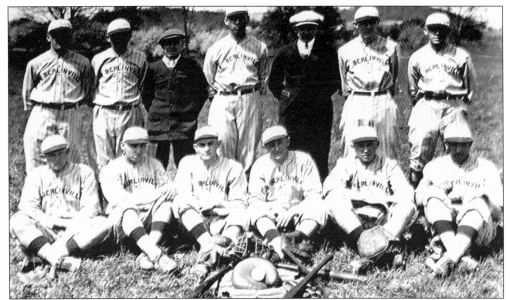

Baseball was the main sport in the area, continuing for many years to be a popular pastime. Folks were eager to sit and root for their favorite team. In 1926, the ballpark was located on Montgomery Avenue. This 1936 photograph shows the New Berlinville Baseball Club. From left to right are the following: (first row) Wayne Smith, Walter Heacock, Melvin Frey, Milky Stauffer, Leroy Hoffman, Leon Fry, and Woodrow Eddinger; (second row) Leonard Moyer, Harvey Moser, John Hartman, Earl Moyer, Morris Youse, Howard Eddinger, Leroy Gilbert, and scorekeeper Lloyd Hess. Linwood Youse served as the bat boy.

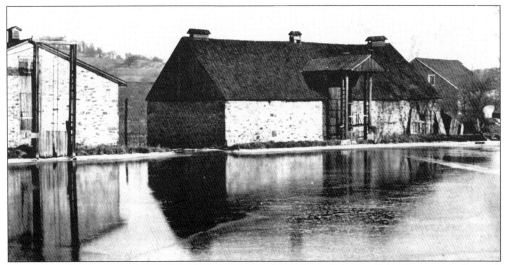

The Seisholtz Dam was located at the present Mel-Dor Hotel (just off the Route 100 bypass) in New Berlinville. It was used to dam up water in the fall, to allow the formation of ice in the winter.

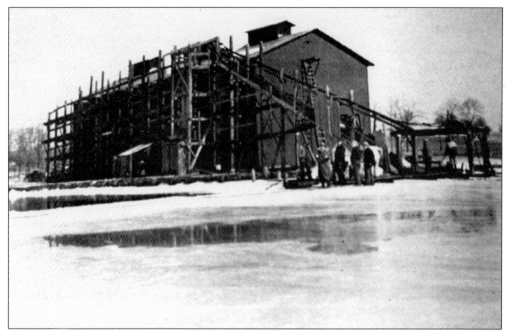

Shown here is the process plant at the Seisholtz Ice Dam, which was originally owned by John Bittenbender and later purchased by Alfred Seisholtz (thus giving the dam its name). Horses were used to help cut the ice. On one occasion, the ice broke and a horse fell through; a gangway was made to save the horse. Ice markers (which would cut two inches to three inches into the ice surface) and saws were used to break through the ice, then the ice was scraped and squared off.

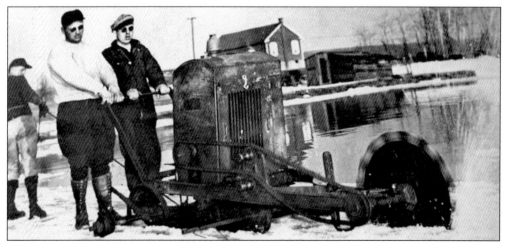

Several men were needed to handle the large, heavy ice-cutting machine on the dam. This machine cut the ice in long, wide strips, which were then moved toward the processing plant. Built during World War I along with the ice house, the plant operated all year long.

The machine cuts ice into small slabs for delivery. Ice was supplied to the New Berlinville Hotel and also to area homes.

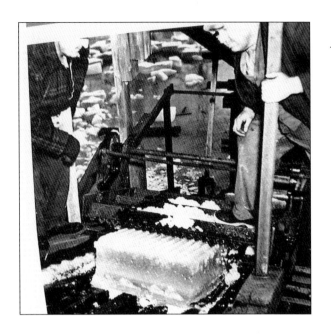

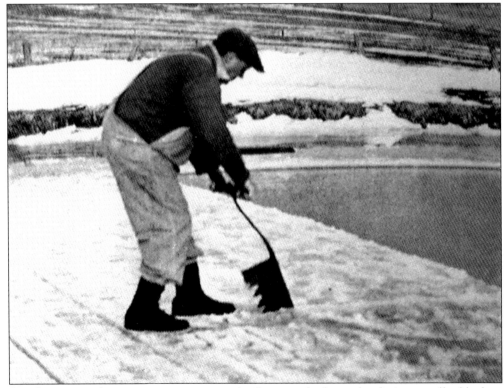

Another step in the ice process was using a knife to cut the large chunks into smaller blocks.

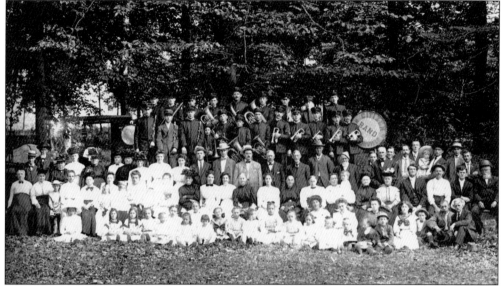

The New Berlinville Band delighted many at the Lewis Bechtel Picnic Grove. In years past, popular local bands provided entertainment for church picnics.

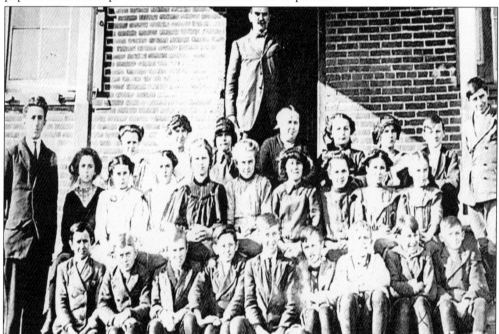

Frank Stauffer was the teacher at the old New Berlinville School. The class of 1912 included, from left to right, the following: (first row) Clyde Seltzer, Wayne Koch, Paul Renninger, Elmer Rush, Clarence Gilbert, Paul Nuss, Ernest Nuss, Isaac Henry, and Irvin Downer; (second row) Walter Davidheiser, Bertha (Renninger) Gruber, Helen (Frey) Fryer, Verna (Reitnauer) Geisler, Agnes (Rieser) Yoder, Helen (Rothenberger) Rhoad's, Helen Ritter, Mae Henry, Sara (Johnson) Nyman, and Alice (Johnson) Schonely; (third row) Lula Nuss, Alice (Romig) Deysher, Martin Ritter, Eva Spohn, Alma (Muttard) Keiser, Alice Herbst, Elmer Bittenbender, and Paul Houck. Mr. Stauffer is standing at the back.

Five

BOYERTOWN

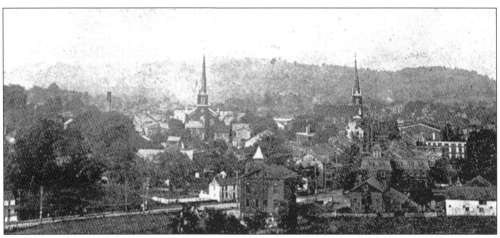

The early morning fog hovers over the streets of Boyertown. The church steeples clearly point to the sky above for all to see. The hills in the background are probably filled with fruit ready to be picked at the orchards that lined the surrounding areas. This view was photographed from Cannon Hill.

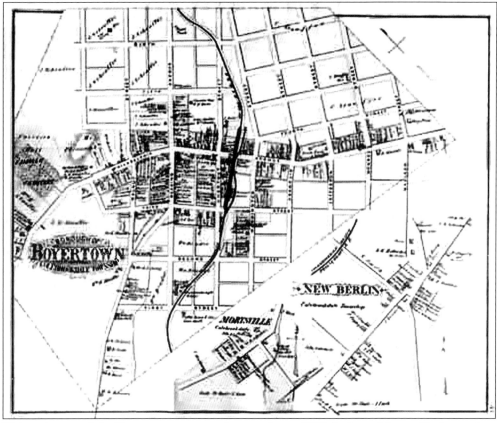

This early map of the Boyertown area was drawn prior to 1883. It shows Morysville, located on South Reading Avenue. Morysville later became the home of Morysville Body Works, West Motor Freight, and the Wren Mansion.

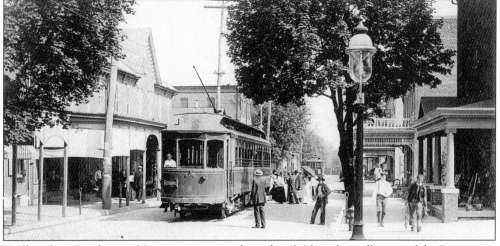

Trolleys from Reading and Pottstown met at the railroad. Plans for trolley travel for Boyertown residents did not stop with the road from Reading. Finally, with the freeing of the Colebrookdale toll road (Swamp Pike) in 1901 and the granting of rights over Boyertown's streets by the town council in 1906, building activity began for this new route.

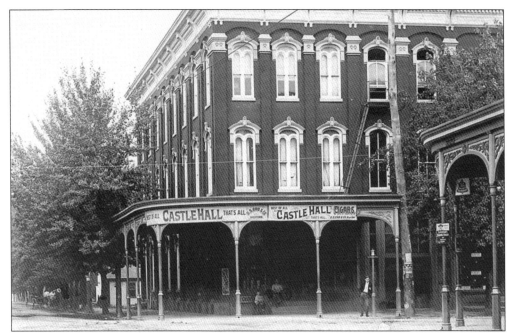

To current residents, it is hard to believe that the cigar business was so prominent in the area and that the factories were major employers. The first facility, started in 1864 by D. S. Erb, was known as the Erb Cigar Factory. In 1882, Erb built a new three-story building at the corner of Philadelphia and Reading Avenues. This building is still located at that site. The factory produced 400,000 cigars a month. Several other cigar factories in Boyertown produced brands such as Castle Hall, Henrietto Cinco, and El Producto.

In this 1872 photograph, Harrison Houck drives the hearse at right. The building on the right, at the southeast corner of Philadelphia Avenue and Chestnut Street, was his residence and funeral parlor. Next door was a tailor shop, and next to that, the Houck Furniture Store. A restaurant occupied the basement of the furniture store on the left.

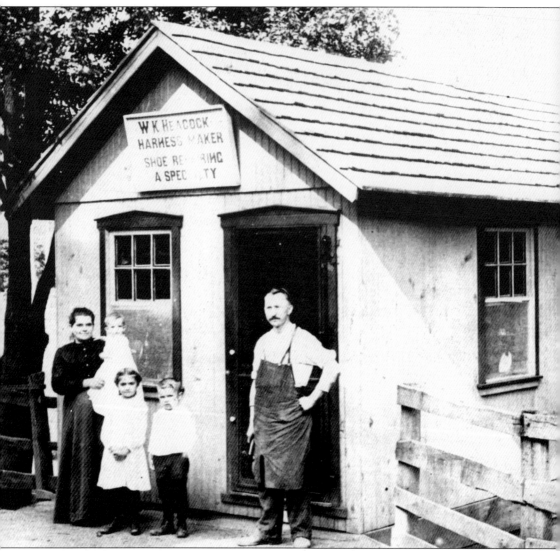

Willis K. Heacock stands with his family in front of his harness shop, where he did leather work and shoe repair. Heacock was quite versatile, as was the standard during those days: he also operated a hair-cutting establishment on Saturdays.

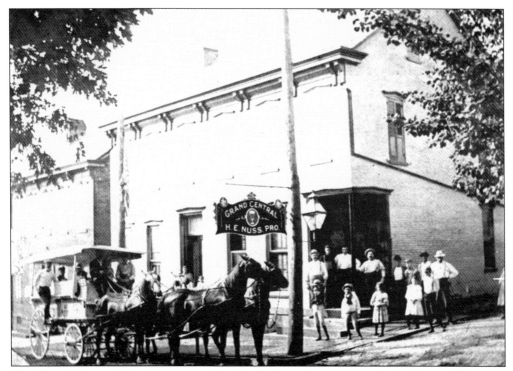

The Grand Central Hotel was owned by H. E. Nuss. Later renamed the Central House, it was converted into a rooming house on Philadelphia Avenue, across from what was once the State Store.

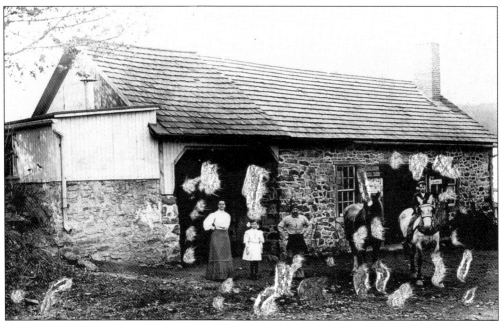

The horse was a valuable commodity likely owned by every family. This local blacksmith shop ensured horses' hooves and shoes were healthy and that the shoes were replaced as needed. There are still several blacksmiths in the area, but the art is dying with the times.

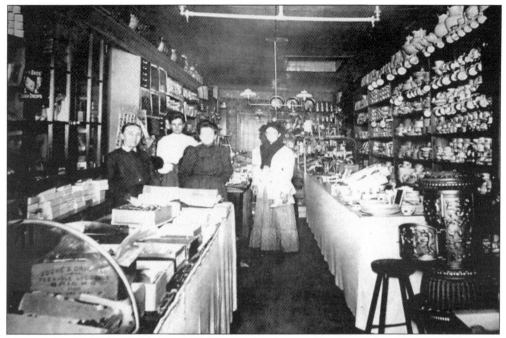

This store occupied part of the old Johnson's Market on North Reading Avenue. The store closed *c*. 1908 but was later reopened by Wilson Weiser, who operated a grocery there.

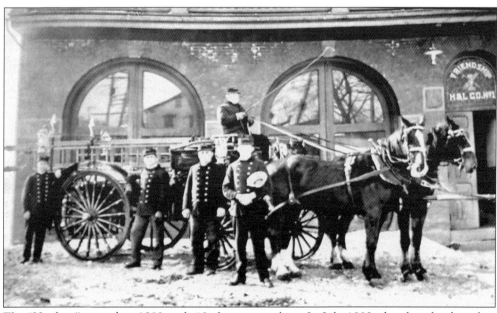

The "Hookies" started in 1882 with 13 charter members. In July 1882, they bought their first piece of equipment, a hand-drawn hose cart. Later, they purchased a ladder truck for $700.

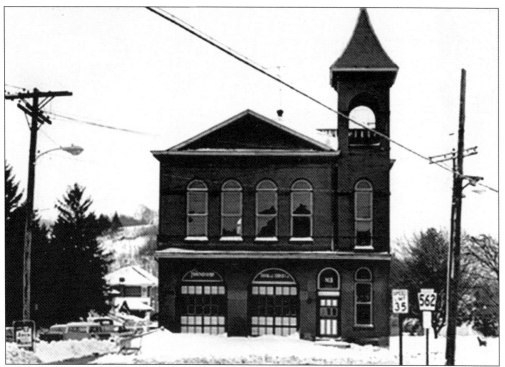

In 1901, the Hookies, needing a new home, purchased from the Reading Mining Company a building at the intersection of Reading, Second, and Warwick Streets. Triangular in shape, the building remained their home for many years. The original cost was $750, but the mining company returned $300 to the fire company for the purchase of much-needed equipment.

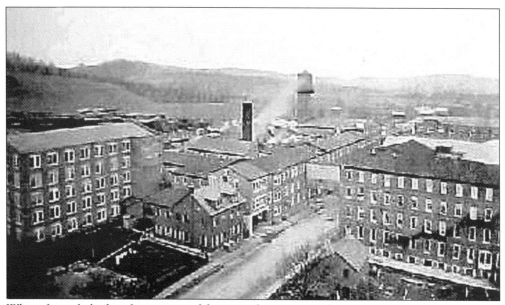

When funerals had to be postponed because there was no local producer of caskets, it was decided to build the Boyertown Burial Casket Company in 1893. The facility, located on Walnut Street, earned the label of being one of the best casket manufacturers.

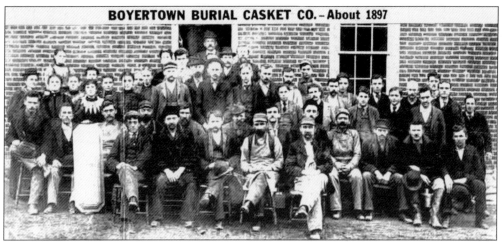

BOYERTOWN BURIAL CASKET CO. – About 1897

The first workers at the Boyertown Burial Casket Company appear here. When there was a death in the family, relatives of the deceased would travel to a main staging area, where the sad task of selecting a casket would be made. In later years, Boyertown Burial Casket became just one of many industrial factories that closed their doors.

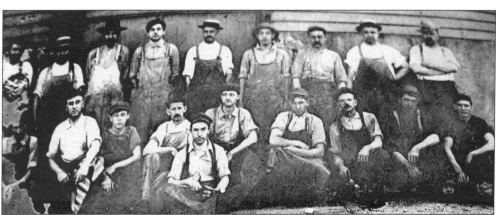

The Boyertown Carriage Works is pictured in 1912. On December 3, 1872, Jeremiah Sweinhart announced the opening of his new carriage factory. It was to become the oldest Boyertown industry, as it had begun after the town's incorporation in 1866.

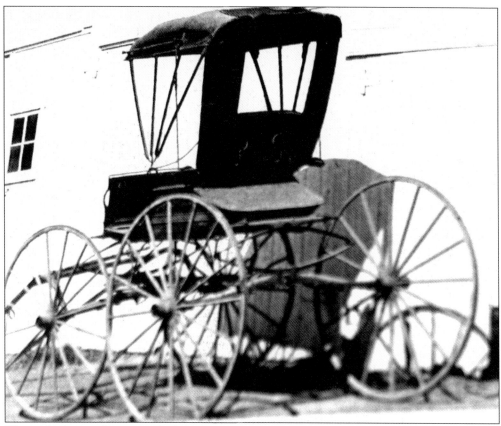

This early doctor's buggy was built by Jeremiah Sweinhart. A weather-tight compartment under and to the right of the buggy seat protected the doctor's pill case. The high wheels made possible the fording of streams and traveling though mud and deep snow.

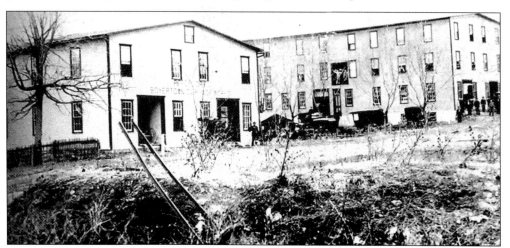

The Boyertown Carriage Works building dates back to the turn of the 19th century. In 1855, a new factory was built. The next year, Frank Hartman took over, turning the business toward a more utilitarian purpose by manufacturing a wide variety of working vehicles, but still maintaining the goal of fine workmanship.

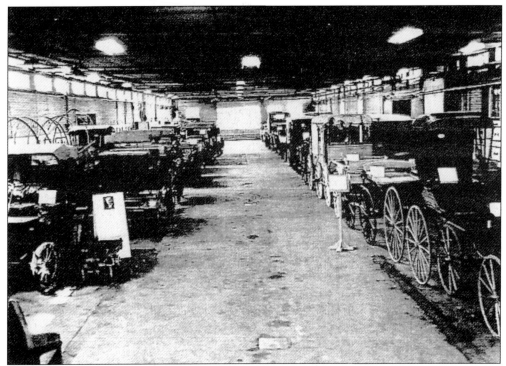

These beautiful carriages were manufactured over the years at the Boyertown Carriage Works. Since this was the primary mode of travel at the time, Boyertown Carriage Works was quite successful, and the vehicles were known for their quality and superb workmanship. Many of the carriages can still be viewed at the Museum of Historic Vehicles in Boyertown.

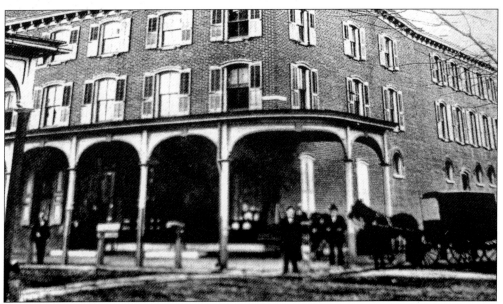

Levi LeFevre ran a hardware store in 1882. In later years, the store increased its items, becoming a very prosperous department store that included clothing, shoes, and hats. This was the first department store in Boyertown to carry a diverse product line.

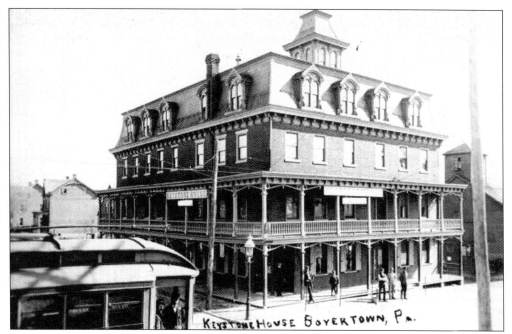

The magnificent hotels of the 1800s were the places to be seen. During that time, they were also centers of political functions, especially the Keystone House. In 1876, Mr. Yost, after recently acquiring the business and renovating the hotel, made arrangements for a reception for the two Democratic presidential candidates. The event featured several bands, refreshments, and speeches.

This independent school (a log cabin) was on the Stengel Farm, located at Orchard Lane. Inside, a slate was found bearing the date 1700. Some of the schoolteachers were paid by the pupil, at a rate of 2.5¢ to 3¢ a day.

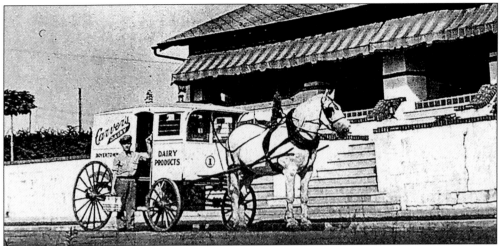

Newton "Newt" Carver delivers milk in glass bottles, with his gray horse Colonel pulling the dairy wagon. It has been said that Colonel knew every stop, and that he could go on his own. Colonel was so popular that each year he was given the honor of leading the big Halloween parade. When the horse grew too old, Carver gave him to a local farm, but he could not be handled there, and his former owner took him back. Carver delivered milk several times a week to homes in the area well into the 1950s, but of course, by that time, motorized trucks had replaced the horse and buggy.

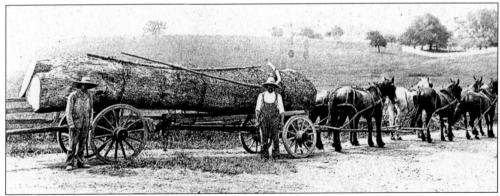

Irvin Moyer (left) and Allen Muthard take lumber to Bahr's Sawmill. This photograph shows their journey at the corner of Third and Madison Streets in Boyertown.

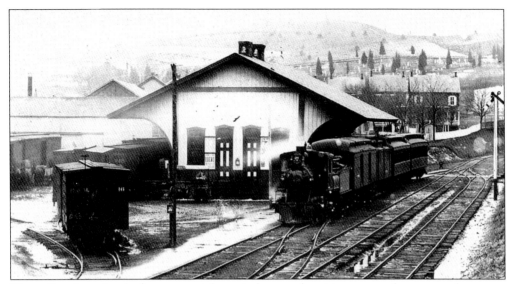

The railroad station had separate ticket windows and waiting rooms for men and women. Leaving Boyertown, the "Milk Train" continued its route toward Pottstown. There, the cans of milk changed to another train headed for Philadelphia.

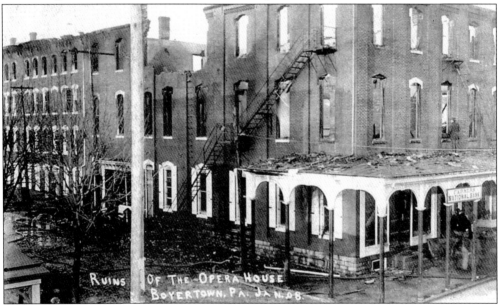

At the Rhoad's Opera House in 1908, a kerosene lantern was accidentally knocked over, which started a fire on the opera house stage and ignited gas from the stereopticon. In the panic that followed, 170 people perished when they were unable to escape from the second-floor auditorium. The crowd was unable to find and use fire escapes, and the exit doors could not be opened outward; therefore, the crush of bodies effectively locked people inside the burning building. The state legislature passed two bills into law in May 1909 as a result of the Rhoad's Opera House fire. Act 233 addressed installation of safety features in similar buildings, such as outward-opening doors, multiple exits from second floors, properly lit exterior doors from backstage areas, and easily accessed and visibly marked fire escapes. Act 206 required fireproof booths for projector machines and stereopticons.

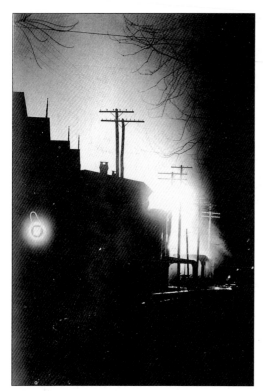

Fire burned down the original opera house building in 1908. More than 170 people died in that fire. Their remains, mixed with ashes from the building, were buried in a common grave in Fairway Cemetery. According to police reports, the cries and moans of those who died could be heard from the grave.

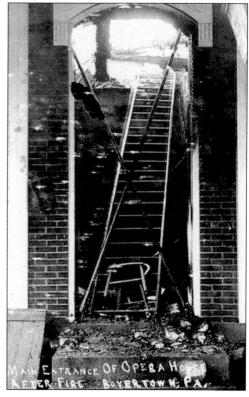

Thousands traveled from all over to attend the funerals following the Rhoad's Opera House fire. Special trains and trolleys brought people from other cities to view the town that suffered such a tragedy. Temporary morgues were set up all over town. Funeral directors came from miles away. Complete families were killed. Virtually everyone in the area was affected. Today, the fire is considered one of the worst in history, and many fire codes and fire safety laws were enacted as a result.

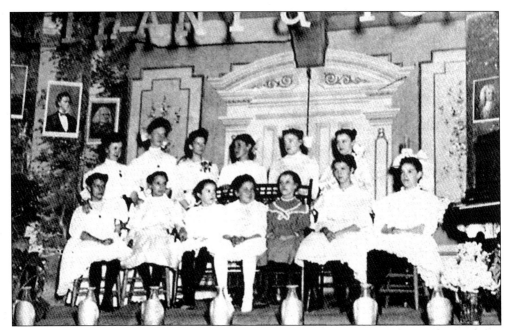

These cast members from the opera house reportedly escaped safely. One survivor reported that within five minutes the screaming inside had stopped.

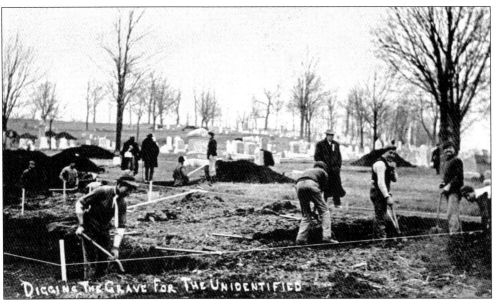

DIGGING THE GRAVE FOR THE UNIDENTIFIED

The Rhoad's Opera House fire killed 170 people, about half of whom were crammed into a second-floor auditorium to see a church-sponsored performance, followed by a series of slides of the Holy Land. A combination of an inexperienced projectionist, the flammability of the gas-based illumination for the projector, over-turned footlights that ignited curtains, and inadequate fire escapes resulted in a jam that trapped many people inside. Philadelphians and others contributed $18,000 in relief funds; 100 Boyertown citizens volunteered to dig the graves; three morgues were established; and an estimated 15,000 people attended funerals on a single day. In the Fairview Cemetery, 105 new graves were dug.

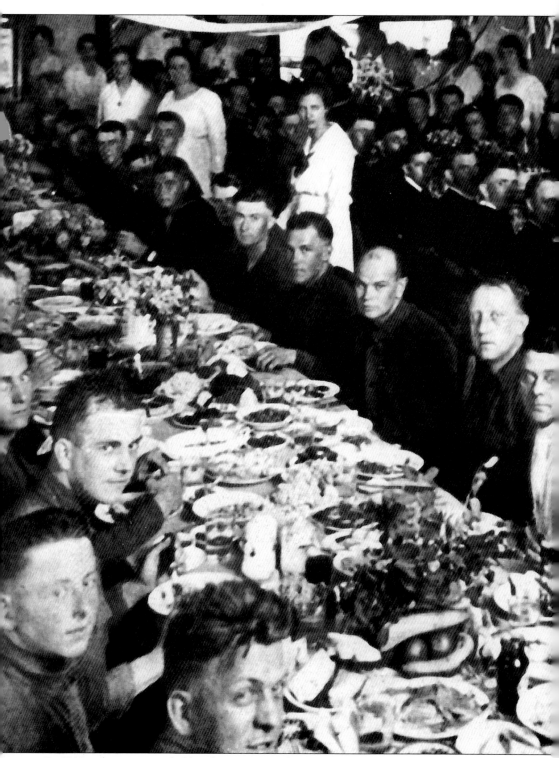

In 1919, a banquet was held to honor returned servicemen from World War I. The smiles on these faces indicate the relief to be home safely and finally have a good home-cooked meal.

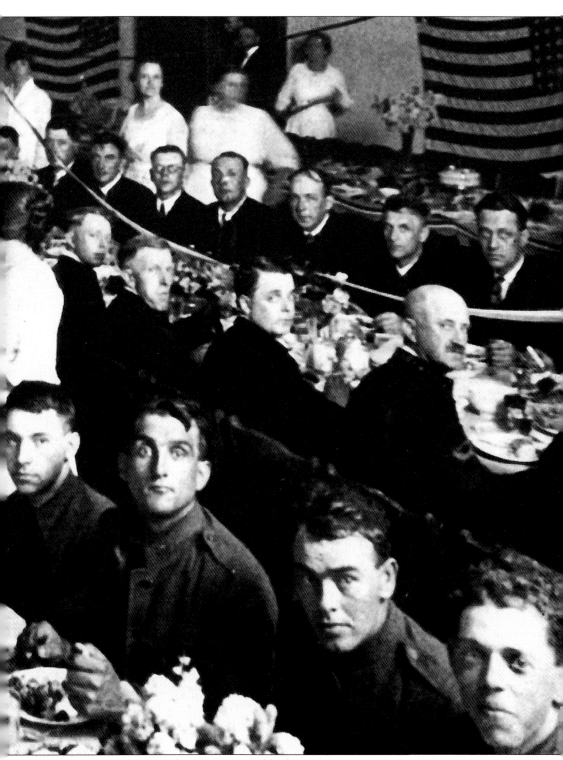

These men were very young, but grew up quickly during war times.

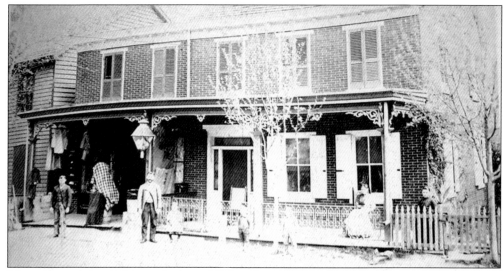

The store in Morysville was built *c*. 1880 and was bought by Elmer Boyer in 1918, which reportedly was the year of the deadly flu. There was never a post office in Morysville, and David Boyer delivered the *Reading Eagle* (the Reading newspaper) to the town's residents. He also would use his Express Wagon to pick up items delivered by trolley freight from Reading. The Engle family is shown standing in front of the store in this image.

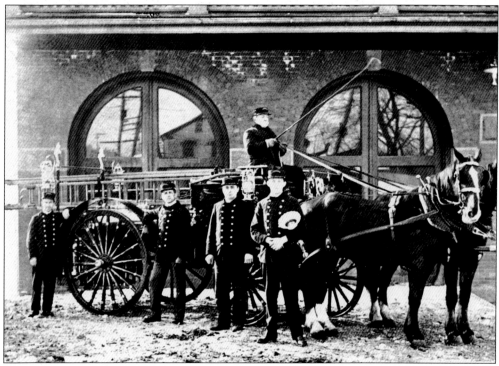

These fine men volunteered their time at the Friendship Hook and Ladder Fire Company. Imagine the time it must have taken to travel by horse to get to the fire and attempt to save the structure and possibly lives. These volunteers risked their own lives, and we owe them a debt of gratitude.

Dr. Charles B. Dotterer, called "Doc," was known for his interest in transportation. He owned a Stanley Steamer air-cooled, later a Franklin, and then an Austin. Boyertown's first motorized fire department was provided by Doc and his Winton. Young men would play tricks on him, and he would find his Austin lifted onto the pavement when he came out of the house. One time it was even lifted onto the porch of the Orioles social club, but Doc did not care; he drove right down over the steps.

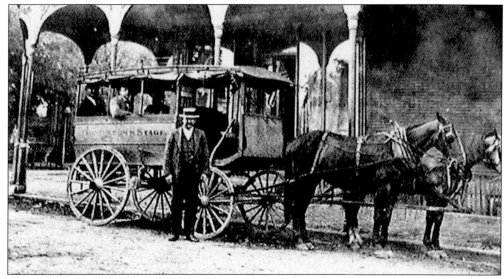

Irvin Landis, shown here, drove the stagecoach that ran between Boyertown and Reading by way of Yellow House, on to Griesmersville, then to Limekiln, and finally to Jacksonwalk. The stagecoach changed horses at Yellow House each way. It also carried mail from Boyertown to Reading until 1902, when the Reading Trolley took over.

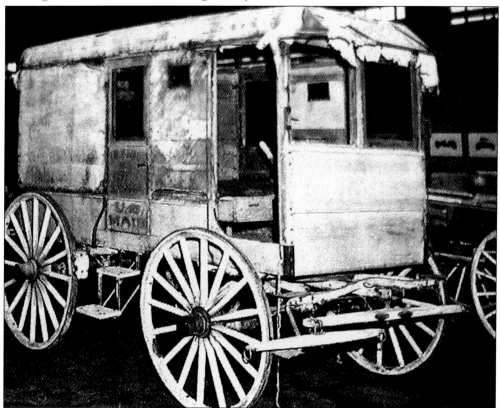

The 1882 Boyertown Stage and U.S. Mail Coach carried mail, passengers, and freight between Boyertown and Reading.

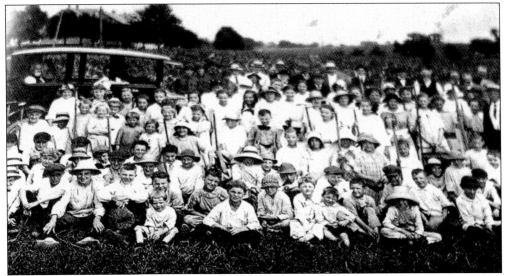

People maintained victory gardens to help ease the hardship of food expenses. Since then, this practice has become a tradition during hard economic times.

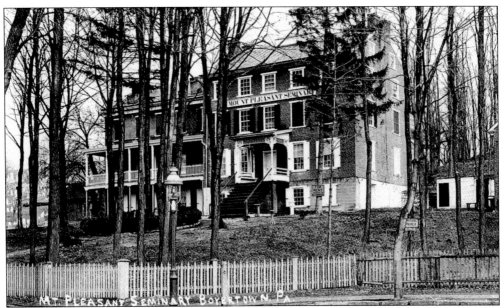

Growing rapidly, the Boyertown area needed advanced education. In 1849, John Stauffer built Mount Pleasant Seminary on West Philadelphia Avenue. Attendance was so good that the building was enlarged in 1855 to accommodate 50 boarding students and 75 day students. Studies included arithmetic, geometry, English, grammar, philosophy, chemistry, physiology, history, German, bookkeeping, and reading. In the 1880s, the Mount Pleasant Seminary became a summer resort before it was torn down to build the Boyer residence.

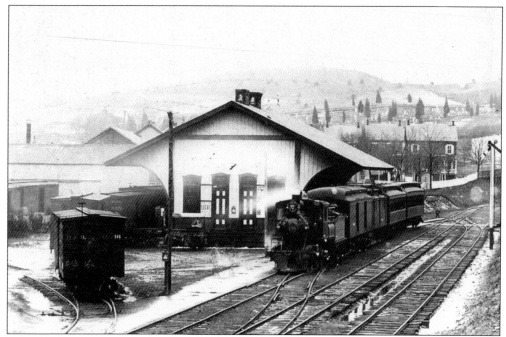

What a day when the first train arrived in Boyertown! The 10:15 "Special" from Pottstown was all decked out with flags and bunting. Railroad travel soon became a part of everyday life.

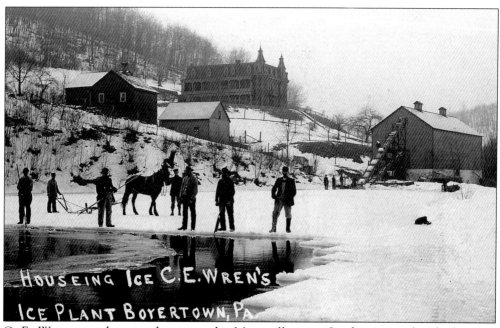

C. E. Wren owned an ice house in the Morysville area. In this view, the thickness is measured and the ice is cut to transfer to the plant. On the top of the hill, the Wren residence can be seen.

Shown here are local men who were drafted for World War I. Drafted men were taken by car to the induction center in Birdsboro, where they received physicals, and then were transported by train to their training centers.

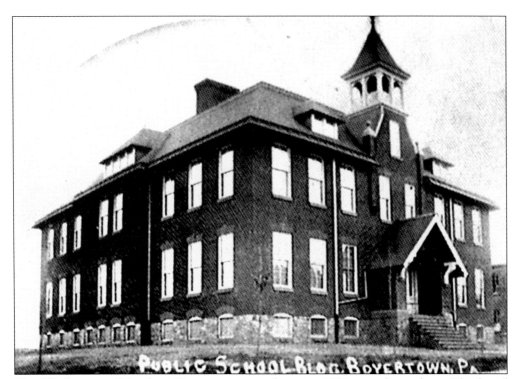

The Washington School in Boyertown, seen here in 1909, was located on Third and Washington Streets. Students had outgrown the schools in the area; therefore, this new two-story brick building was constructed with four rooms on each floor.

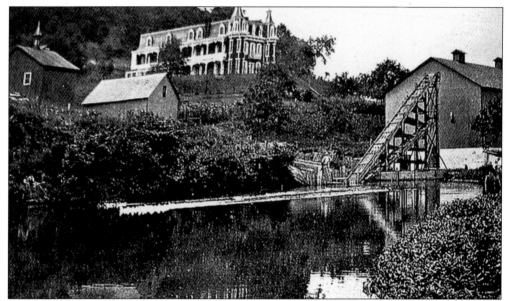

The Wren Mansion was situated on the hill along Old Route 100 in Douglass Township toward Little Oley. In the early 1870s, Major Wren moved to Boyertown and unsuccessfully prospected for iron ore along Colebrookdale Creek. This building was the summer home for the Wren family. In later times, Anne Brady operated a convalescent home here.

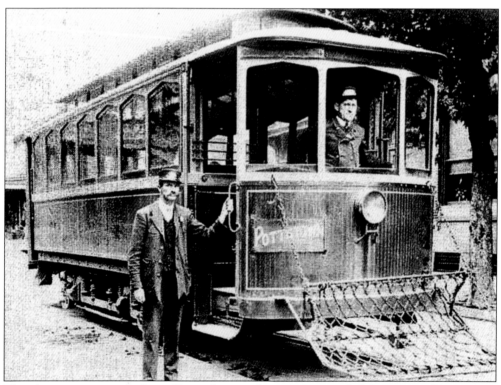

This closeup view reveals the trolley and its conductors who traveled the streets of Boyertown.

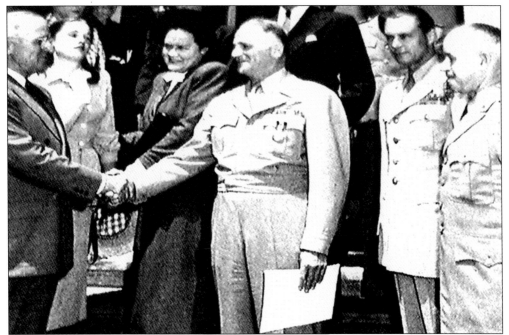

Boyertown had a hero too, and his name was Carl Spatz. He attended West Point Military Academy. When World War I broke out, he entered the military as a lieutenant and attained the rank of captain in 1917. He shot down three German Fokkers behind the lines and was awarded the Distinguished Flying Cross.

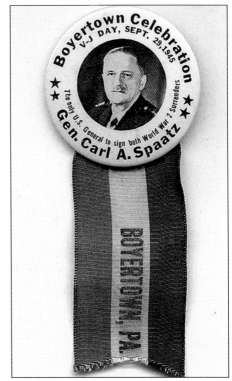

This medal depicts the heroism of Capt. Carl Spatz. Not only a local hero, he has been recognized the world over.

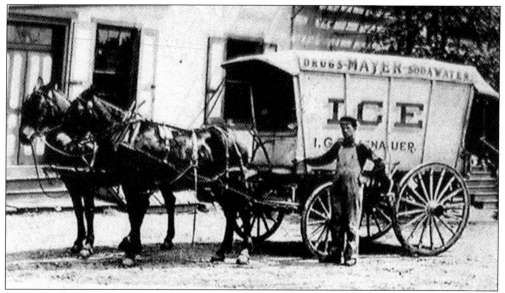

The Irwin Reitenauer Ice Company delivered ice in the Boyertown area in the wagon shown. Families relied on ice to keep their food from perishing.

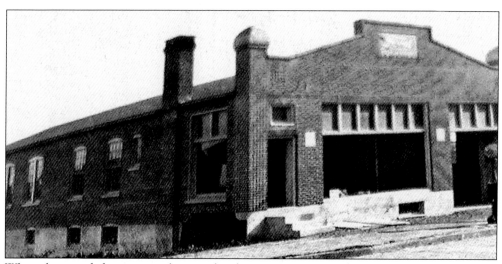

When they needed repairs to their mode of transportation, residents were seen entering the Elder Garage in Boyertown.

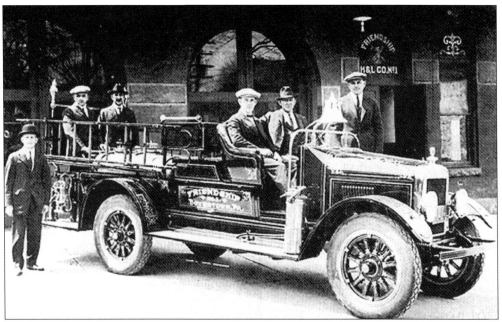

Finally, the move occurs from horse-drawn vehicle to motorized truck.

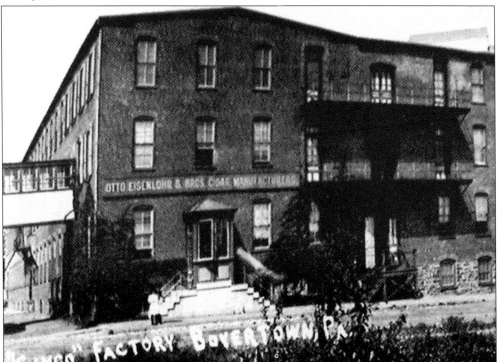

The Cinco Cigar Factory, shown here, arrived in town in 1902. The Otto Eisenlor and Brothers Company erected a large three-story building and, by 1906, had built an addition. At this time, the company employed 450 people and produced more than 20 million cigars annually. The cigar workers labored hard for low wages, and holiday time put extra demands on them. One consolation was that they were permitted to take home two cigars at the end of each day.

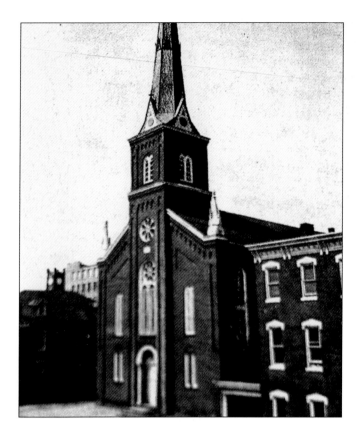

St. John's Lutheran Church expanded, adding a new Sunday school annex, which was completed in 1927 and dedicated on January 22, 1928. Due to unsafe conditions, the steeple was removed in 1933.

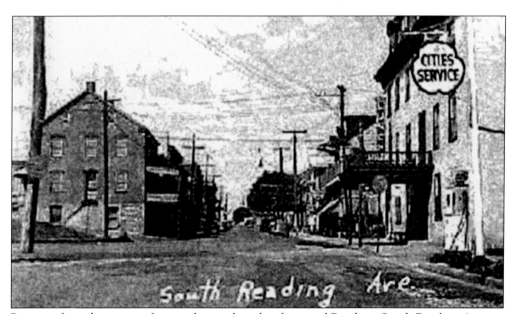

Running from the center of town, this roadway heads toward Reading. South Reading Avenue has been extensively altered since this 1940s view.

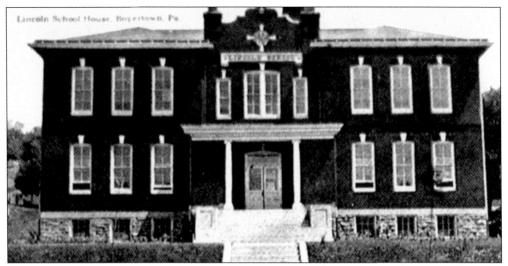

In March 1909, the Boyertown School Board elected to construct the new Lincoln School, a two-story brick structure with four rooms on each floor. The curriculum was the same as before, but with the addition in 1913 of manual skills training, such as carpentry, for boys and sewing for girls.

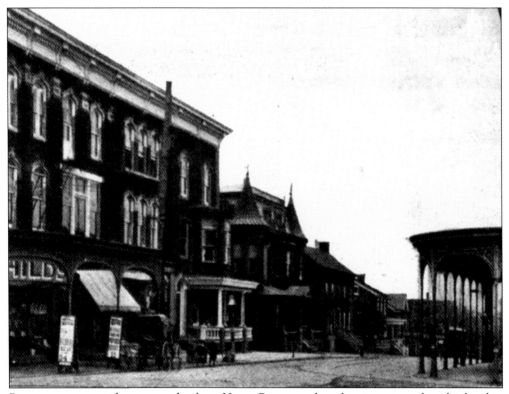

Boyertown arose at the crossroads where Henry Boyer purchased an inn across from his brother Daniel's store in 1801. The area was originally settled in the early 1700s by Germans, Swiss, and French Huguenots. In 1814, a German Lutheran church was established, and the Reading and Philadelphia Avenue crossroads became known as Boyers. Between 1865 and 1900, the railroad came to town, creating the most significant and lasting change.

This cannon is located on Cannon Hill on Franklin Street in Boyertown. This area, dating back to 1876, is a historical site from which one can have a long, clear view of the Boyertown area.

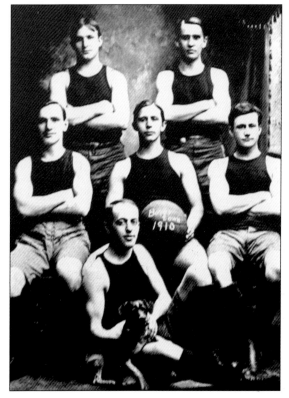

The Boyertown basketball team poses in 1910. In addition to playing baseball or basketball, adults wanted to spend their time doing something less strenuous such as croquet or quoits. There was no age limitation on these games.

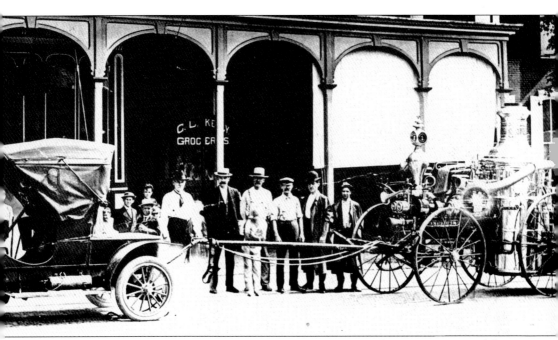

Boyertown's first motorized fire equipment was provided by Charles B. Dotterer and his Winton automobile.

In this beautiful view of a residential area in Boyertown, the moon shines brightly on a cold wintry night.

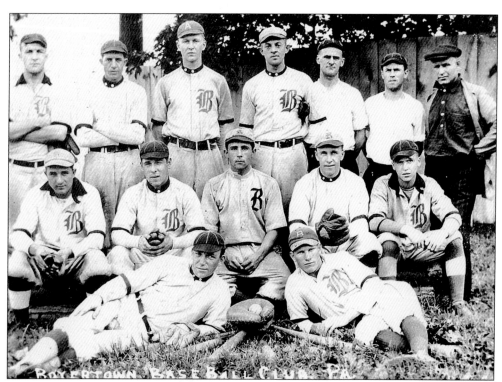

Baseball was a popular sport in all towns.

120

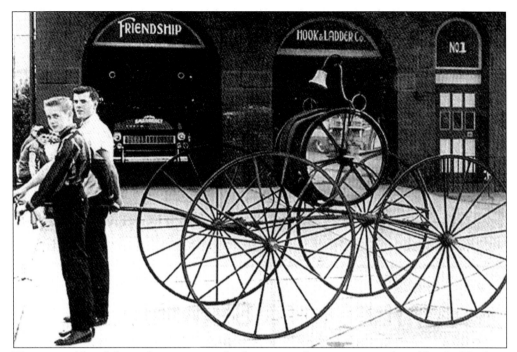

The original hand-drawn hose cart was the first piece of equipment purchased by the Hookies. On July 7, 1882, a release was signed for the Pennsylvania Railroad to ship the cart free of charge. The fire company motto, adopted then, remains today: "We seek to rescue and save."

This early photograph dates back to 1900. Locals from the Boyertown area, these "bathing beauties" were, from left to right, Sue Gabel, Bessie Nester, unidentified, and Bertha Wetzel (standing in back). In 1900, swimsuits covered nearly the entire body.

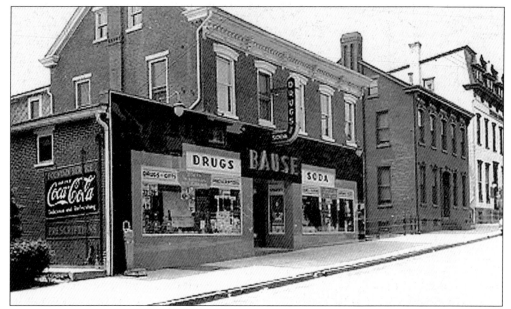

Bause's Drug Store went through several renovations during its time. Located on Philadelphia Avenue, it was the primary business for providing medications to local residents, but the store carried all types of products. At one time, the store included a soda fountain and tables, where teenagers and their parents could gather and enjoy themselves. Bause's Drug Store remains today on Philadelphia Avenue in Boyertown.

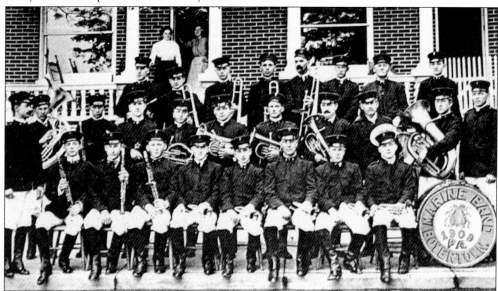

The 1909 Marine Band of Boyertown was led by Al Mercer. Members are, from left to right, as follows: (first row, seated) unidentified, Robert Henry, Charles Schwanger, Lloyd Ritter, Warren Hutt, Alvin Steltz, Robert Gift, and Clyde Landis; (second row) Harvey Landis (tuba), John Garber, Charles Hartman, ? Griesmer, Warren Swavely, Anthony Weller, unidentified, Washington Seidel, Claude Smith, and James Brown; (third row) Edwin Grim, unidentified, Harvey Spohn, Harry Fisher, Jasper Yoder, Charles Mutter, unidentified, and Charles Spohn. The ladies on the porch, at the back, are Maggie Romich (left) and Mrs. ? Nester.

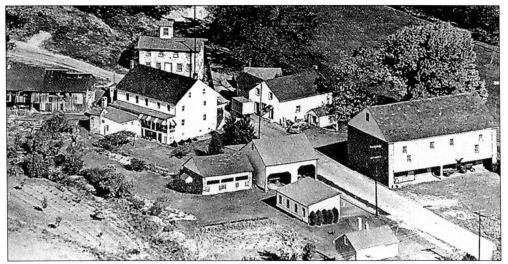

The Bahr homestead dates back to the early 1700s, when Mary Gabel married Jacob Bahr, and their union gave birth to Bahr's Store. In 1897, Jacob rebuilt the sawmill on the property. The store and sawmill have been operated by members of the Bahr family since these early days. The sawmill was first run by water power (with an oversized wheel) from Grim's Dam. When the dam was built, it took many springs away from the area; therefore, a pump was added next to Bahr's Store, where folks could get water.

These homes along North Reading Avenue, built in the late 1800s and early 1900s, have been well preserved, as the majority are still standing.

This view shows an unpaved Third Street. Dirt roads caused muddy conditions in wet weather and dust in the hot, dry weather. Residents had to either water down the streets or pay to have their area oiled. When the trolley tracks were laid, the streets were paved.

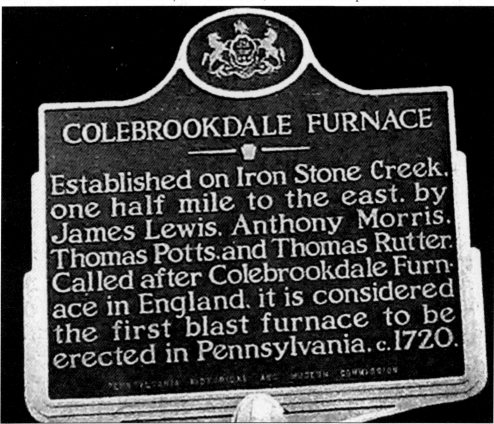

COLEBROOKDALE FURNACE

Established on Iron Stone Creek, one half mile to the east, by James Lewis, Anthony Morris, Thomas Potts, and Thomas Rutter. Called after Colebrookdale Furnace in England, it is considered the first blast furnace to be erected in Pennsylvania. c. 1720.

Located on present Route 562 (also known as South Reading Avenue), this sign is seen when entering from the Reading area. Colebrookdale Furnace was so named to perpetuate the English furnace of that name, owned by Abraham Darby, an English Quaker. By 1720, the stone buildings had begun operations. The boundaries of the Colebrookdale area in the 1700s are not the exact boundaries today.

Edwin W. Keim picks Oliver apples from a 10-year-old tree in 1911. This tree produced an average of seven bushels per year.

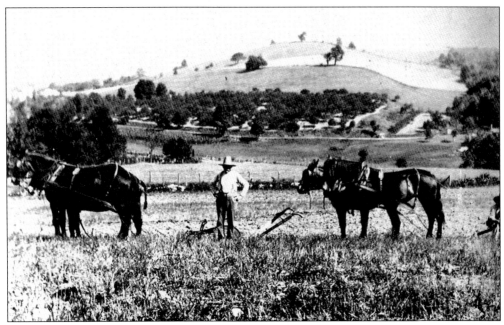

The Edwin W. Keim Farm was just one of many in the area, since the land was rich for growing apples and peaches.

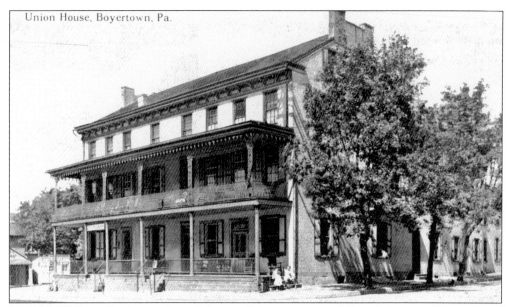

Union House, Boyertown, Pa.

In 1855, William Binder purchased the small log structure of Boyer's Inn, at the corner of Philadelphia and Reading Avenues, and replaced it with a brick building. The name was changed to the Union House. Today, the building still stands but is now known as the Boyertown Inn.

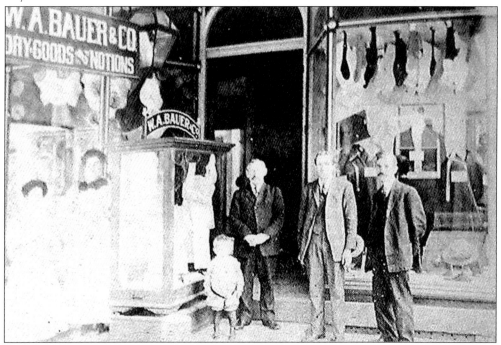

W. A. Bauer Dry Goods was an early day five-and-dime store that carried all types of notions. Saturday nights were special. Shoppers carrying baskets strolled from the produce store to the bakery, to the butcher shop, or to stores specializing in fish and oysters. A credit system was established for the less fortunate, through which items could be picked up during the week and paid for on Friday (pay day). This was called "buying on tick."

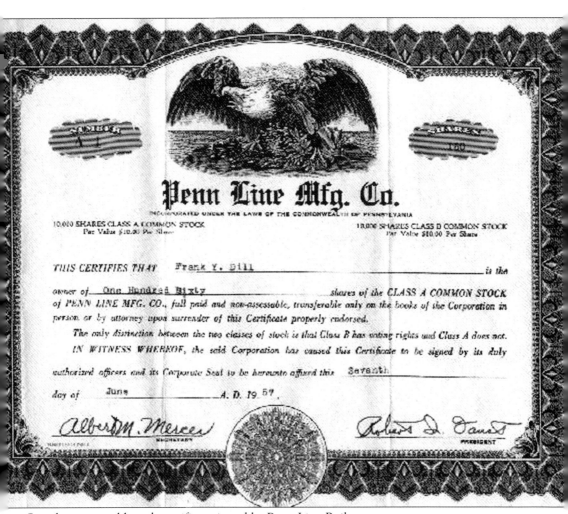

Penn Line Mfg. Co.

INCORPORATED UNDER THE LAWS OF THE COMMONWEALTH OF PENNSYLVANIA

NUMBER A 1

SHARES 160

10,000 SHARES CLASS A COMMON STOCK
Par Value $10.00 Per Share

10,000 SHARES CLASS B COMMON STOCK
Par Value $10.00 Per Share

THIS CERTIFIES THAT Frank Y. Dill is the

owner of One Hundred Sixty shares of the CLASS A COMMON STOCK
of PENN LINE MFG. CO., full paid and non-assessable, transferable only on the books of the Corporation in
person or by attorney upon surrender of this Certificate properly endorsed.

The only distinction between the two classes of stock is that Class B has voting rights and Class A does not.

IN WITNESS WHEREOF, the said Corporation has caused this Certificate to be signed by its duly

authorized officers and its Corporate Seal to be hereunto affixed this Seventh

day of June A. D. 19 57 .

Albert M. Mercer
SECRETARY

Robert D. Dann
PRESIDENT

Seen here is an old stock certificate issued by Penn Line Railways.

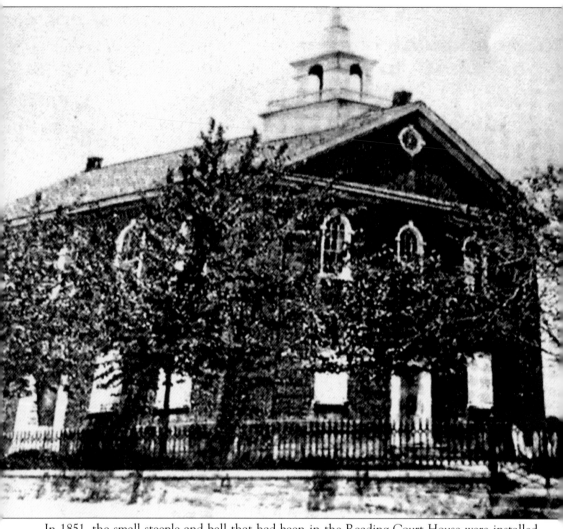

In 1851, the small steeple and bell that had been in the Reading Court House were installed on the Union Church. Later, new lamps and chandeliers were added to the interior of the church, and were lit for the first time on January 28, 1854.